POSTCARD HISTORY SERIES

Vanishing Los Angeles County

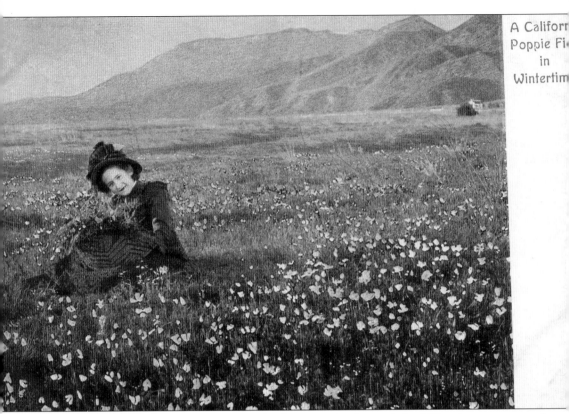

In the early 1900s, the expansive open lands of Los Angeles County's foothill region were covered with fields of bright orange poppies each spring. Visitors often stopped to gather a bouquet of the popular state flower. (Cory and Sarah Stargel collection.)

ON THE FRONT COVER: The Brown Derby restaurant, which opened on Wilshire Boulevard across from the Ambassador Hotel in 1926, was one of the most famous dining spots in Los Angeles. The iconic hat–shaped eatery had vanished by 1980, when a strip mall was built on the site. (Cory and Sarah Stargel collection.)

ON THE BACK COVER: By the turn of the 20th century, citrus growing had become one of Los Angeles County's most important industries. A novelty to tourists visiting from the East, the orange groves were a popular stop on sightseeing tours. (Cory and Sarah Stargel collection.)

Vanishing Los Angeles County

Cory and Sarah Stargel

ARCADIA
PUBLISHING

Published by Arcadia Publishing
Charleston SC, Chicago IL, Portsmouth NH, San Francisco CA

Printed in the United States of America

Library of Congress Control Number: 2010921995

For all general information contact Arcadia Publishing at:
Telephone 843-853-2070
Fax 843-853-0044
E-mail sales@arcadiapublishing.com
For customer service and orders:
Toll-Free 1-888-313-2665

Visit us on the Internet at www.arcadiapublishing.com

We would like to dedicate this book to Professor Wagstaff, Pinky, and Baravelli. Their inspiration was essential for helping us to complete this book.

CONTENTS

ACKNOWLEDGMENTS

We would like to acknowledge the love and support we have received from our friends and family, especially our parents.

We would also like to thank Arcadia Publishing for allowing us to play a role in preserving the wonderful history of Los Angeles.

All of the postcards in this book are from the authors' personal collection.

INTRODUCTION

Home to more than 10 million residents, modern Los Angeles County bears little resemblance to the county as it appeared just over a hundred years ago. When Los Angeles County was established in 1850, shortly before the state of California was admitted to the United States in 1851, the city of Los Angeles was a small town with only a few thousand residents. The rest of the county was primarily a rural place of cattle ranches and some agriculture.

After a transcontinental railway connection was completed in 1876 by the Southern Pacific Railroad, followed shortly after by a second connection by the Santa Fe Railroad in 1885, the slow pace of life that had characterized the county came to an abrupt halt. As the two competing railroads embarked on an intense rate war, thousands upon thousands of curious Easterners and Midwesterners began flocking to the region. Some came seeking adventure and opportunity, while others sought to take advantage of the healthful Mediterranean climate. New towns appeared overnight as real estate prices boomed, and construction of new homes and businesses abounded.

As the frenzy of the 1880s boom tapered off, Los Angeles County found itself entering the 20th century a changed place. Cattle ranching had become a thing of the past, and small communities now thrived on former ranchlands. As the fame of the mild Southern California winter had spread, resort hotels catering to wealthy Easterners were constructed throughout the scenic foothill district, especially in Pasadena. Small farms grew a variety of crops, and the first orange groves had been introduced with great success throughout the foothill region. Agriculture developed as the county's primary industry, and citrus became one of the county's most important and iconic crops.

Regional development increased in the early 1900s when Henry Huntington's famed Pacific Electric red cars began service. As new lines appeared yearly throughout the region, residents were enabled to move to the small towns throughout the county while still maintaining convenient access to the employment, shopping, and entertainment of burgeoning downtown Los Angeles. Small communities previously based on agriculture experienced rapid growth, and new residential subdivisions proliferated. This pattern of suburbanization was reaffirmed as the auto caught the imagination of the county's residents, and car travel began to provide another easy means of traveling throughout the expansive county.

With travel throughout the county made convenient both by Pacific Electric line and by car, new attractions began to develop alongside the growing suburban towns. As the Los Angeles Chamber of Commerce sent advertisements nationwide proclaiming the region's ideal climate and the wealth of activities to be enjoyed, tourism became one of the county's major industries. The Mount Lowe excursion, Cawston's Ostrich Farm, Busch Gardens, the Alligator Farm, and the bathhouses, piers, and amusement zones found in the county's numerous beach towns surged in popularity.

After the first movie studios arrived in Hollywood in the 1910s, the region began attracting even more tourists. By the 1920s, visitors hoping for a glimpse of their favorite star flocked to Los Angeles and Hollywood, visiting the many celebrity-frequented restaurants, clubs, and hotels found there. Places such as the Hollywood Hotel, the Brown Derby restaurant, and the Cocoanut Grove at the Ambassador Hotel gained world fame, becoming synonymous with Hollywood glamour. Elaborate movie palaces were constructed both in Hollywood and along the bustling shopping and entertainment corridor of Broadway in downtown Los Angeles. Few star-struck tourists missed the opportunity to attend one of the movie premieres frequently held at the most popular theaters.

One of the few major cities in the nation to experience its primary development period during the same time that the automobile became popular, Los Angeles helped pioneer roadside architectural styles designed to attract drivers. Themed architecture, such as the hat-shaped Brown Derby restaurant, proliferated throughout the county, and new restaurant styles such as the drive-in and the car café were introduced. As automobile travel became common in the 1920s, especially following the establishment of Route 66 in 1926, tourists and migrants began arriving not by train, but by car. Catering to this new brand of traveler, moderately priced auto courts and motels began to line major boulevards. Los Angeles is known for readily embracing the new car culture, and is often credited with inventing, or at least perfecting, both the modern motel and the drive-in.

Despite the new feel that the roadside era brought to the county and the changes that occurred during the Depression, the period of most drastic change for Los Angeles County in the 20th century began following World War II. In its strive to become the major metropolis it is today, many of what had been its most well know features were sacrificed, resulting in a modern Los Angeles County that would be almost unrecognizable to an early 1900s resident. As the booming postwar population caused housing demand to skyrocket, real estate prices rose. Farmers found that their agricultural land was much more valuable when sold for new developments, and orange groves were plowed under to build new residential subdivisions. The once wide-open spaces between small communities were gradually filled in until the county became an almost solid wall of suburban homes. New retail construction also occurred at a rapid pace, until residents hardly needed to leave their own community. As people began choosing to avoid the downtown traffic in favor of shopping and attending movies at the convenient suburban shopping malls and multiscreen cineplexes, the old city center of Los Angeles declined. By the 1970s, once common sights, such as acres of orange groves and fields of wildflowers, had all but vanished.

While shopping malls, chain stores, and cineplexes have prospered, one by one the famed landmarks, restaurants, hotels, clubs, and theaters of Los Angeles have been lost. This volume seeks to revisit a selection of these disappearing places. Over 200 vintage postcard images appear here, providing views of the county's agricultural past, its small town days, some of its famed attractions, hotels, restaurants, and other landmarks, and of its roadside era. While many of these places and scenes are just a memory, there are many that still stand. It is hoped that readers of this volume will be inspired to help preserve the many historic places that remain throughout Los Angeles County.

One

THE LAND OF ORANGES AND FLOWERS

A California Rose Bush. Los Angeles

Early promotional material proclaimed the paradise to be found in the Los Angeles region, luring tourists with stories of oranges growing in winter and of enormous rose hedges blooming year-round. The thousands of postcards mailed east to friends and relatives in the early 1900s served as illustrative companions to these tourist guides. Images such as the one on this postcard were often accompanied by captions declaring the scene to be "common" or "typical."

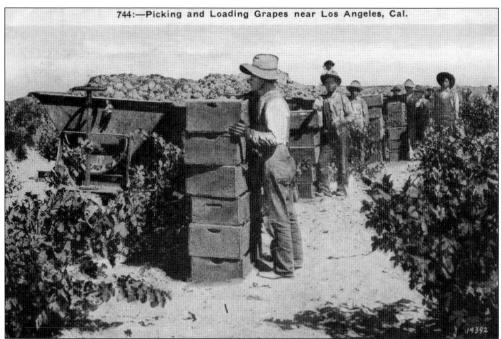

744:—Picking and Loading Grapes near Los Angeles, Cal.

The first grapes in Los Angeles County were grown at the San Gabriel Mission in the early 1800s. Commercial vineyards were planted near downtown Los Angeles in the 1820s, and by the late 1800s grapes were one of the county's top agricultural products. Grape production began to decline as the citrus industry gained popularity in the 1890s.

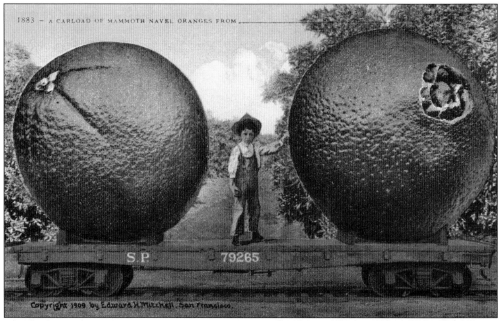

1883 – A CARLOAD OF MAMMOTH NAVEL ORANGES FROM

To emphasize the area's growing potential, postcards of exaggerated fruits and vegetables such as this one became common in the early 1900s. Hoping to entice Midwestern farmers to settle in the county, Los Angeles boosters advertised that with the region's fertile soil and year-round sunshine, farmers enjoyed larger, more bountiful crops than could be grown elsewhere.

10

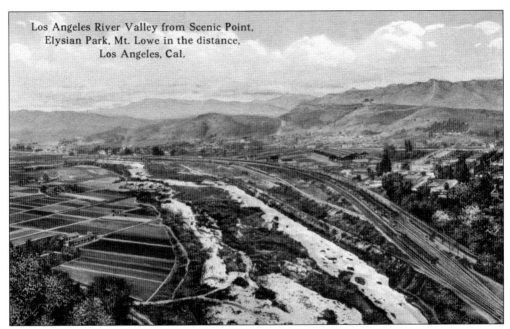

Los Angeles River Valley from Scenic Point,
Elysian Park, Mt. Lowe in the distance,
Los Angeles, Cal.

Facing north from Elysian Park, this postcard depicts the vegetable fields located adjacent to the free-flowing Los Angeles River. Though insignificant for much of the year, during heavy rains the river was subject to serious flooding. After floods in the 1930s caused major damage, the U.S. Army Corps of Engineers encased the river in a concrete channel.

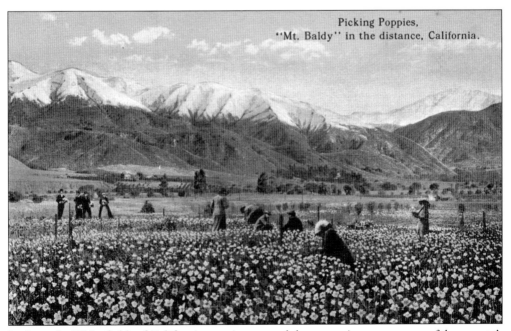

Picking Poppies,
"Mt. Baldy" in the distance, California.

In the early 1900s, fields of California poppies covered the expansive open spaces of the county's foothill region every spring. Tourist excursions often made special stops when the poppies were in bloom so that visitors could gather a bouquet of the popular state flower.

11

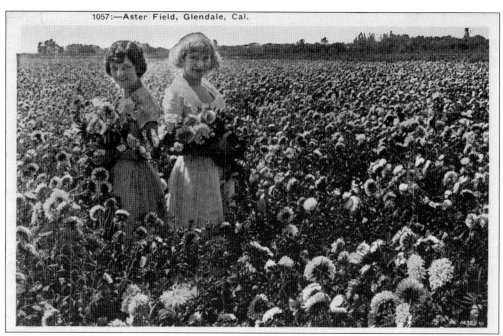

1057:—Aster Field, Glendale, Cal.

Los Angeles County farms featured not only acres of citrus, vegetables, and grains, but also fields of commercially grown flowers. Postmarked in 1926, this postcard depicts two girls among an aster field in Glendale. After the invention of the refrigerated railroad car, flowers grown in Los Angeles County were shipped throughout the country.

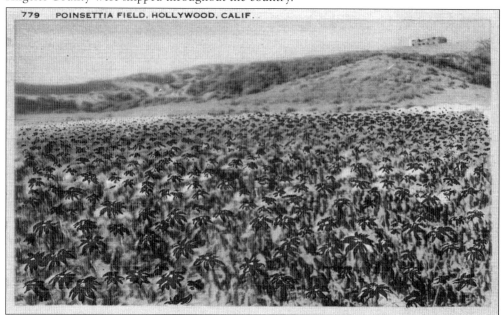

779 POINSETTIA FIELD. HOLLYWOOD. CALIF.

When Albert Ecke settled in Los Angeles in 1906, he became interested in the poinsettia, which grew wild throughout the area. Believing that the winter-blooming plant would make an ideal Christmas flower, Ecke began cultivating fields of poinsettias in Hollywood and selling them at roadside stands in Hollywood and Beverly Hills. As development in Hollywood increased, Ecke moved his ranch to Encinitas, where it continues to be a leading poinsettia producer.

Postmarked in 1909, this postcard depicts a carload of tourists admiring the rustic foothill landscape found in Brand Canyon in Glendale. Scenic roads abounded throughout the countryside of Los Angeles County, and visitors often embarked on day-long auto trips to explore the scenery. At the time a small agricultural community of small farms and citrus groves, Glendale was an ideal place for a pleasant drive.

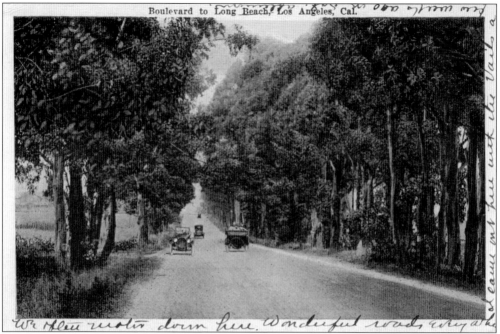

As the automobile surged in popularity, motoring became a popular recreational activity. Scenic drives and tree-lined boulevards, such as this one leading to Long Beach, began to appear, winding through the county's expanse of farms and citrus groves. Early guidebooks frequently listed auto drives among recommended activities, and visitors often noted the good quality of the county's roads. The author of this postcard writes, "We often motor down here. Wonderful roads everywhere."

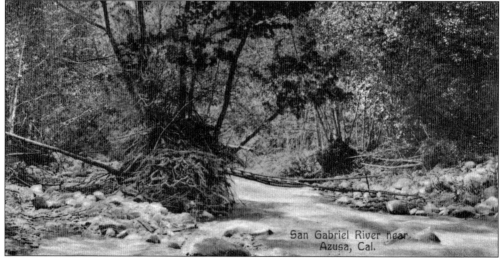

One of Los Angeles County's major rivers, the San Gabriel River is shown here near Azusa, where it enters the county from its source in the San Gabriel Mountains. Along with the Los Angeles River, the San Gabriel River was a primary water source in the county's early days. However, after a devastating flood in 1938, the U.S. Army Corps of Engineers implemented a series of flood control measures. Both the San Gabriel River and the Los Angeles River are now almost entirely cemented in concrete channels.

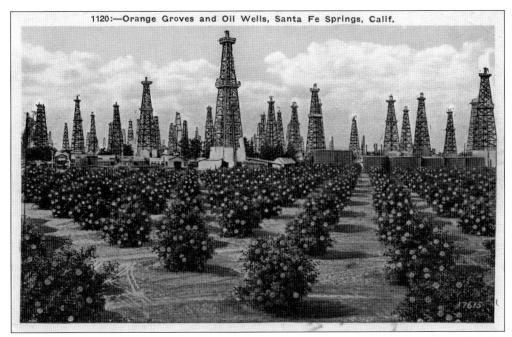

1120:—Orange Groves and Oil Wells, Santa Fe Springs, Calif.

This postcard pictures an orange grove in Santa Fe Springs, with oil derricks behind. After Edward Doheny made the first oil strike in Los Angeles in 1892, oil derricks began appearing everywhere, even in orange groves and backyards. One of the largest oil fields was discovered in Santa Fe Springs in 1921.

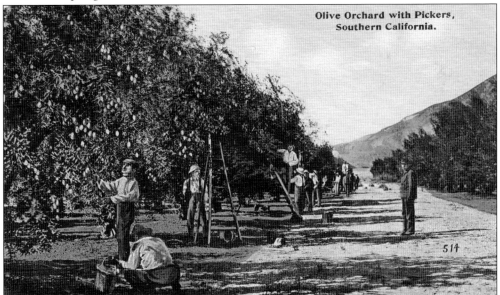

Olive Orchard with Pickers, Southern California.

This 1913 postcard depicts pickers harvesting an olive orchard. Olive production in Los Angeles County centered in the San Fernando Valley community of Sylmar, which was noted as early as the 1870s to have an ideal climate for olive cultivation. The number of olive groves surged after the completion of the Los Angeles Aqueduct in 1913 ensured a steady supply of water. Although Sylmar was annexed to the city of Los Angeles in 1915, Sylmar brand olives and olive oil were known throughout the country.

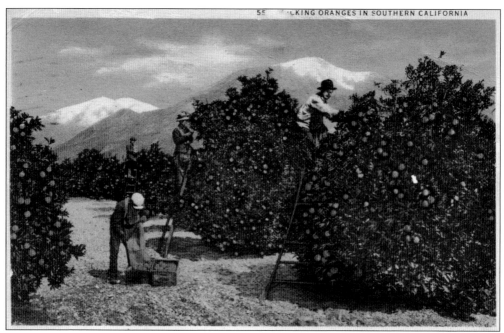

The first orange groves were planted in Los Angeles County at the San Gabriel Mission in the early 1800s. The first commercial groves were planted by William Wolfskill in the 1840s in what is now downtown Los Angeles. The first orange crops were primarily for local consumption, with some sent north by boat to San Francisco. In 1877, Wolfskill shipped the first railroad car of oranges east, and despite arriving in St. Louis two months later, the entire shipment immediately sold out.

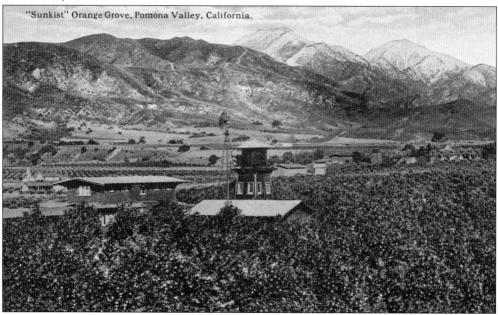

"Sunkist" Orange Grove, Pomona Valley, California.

As population surged in Los Angeles County in the 1880s, many new residents began to plant orange groves, such as the one seen here in the Pomona Valley. The groves became such a common sight in the foothill region that area came to be known as the citrus belt.

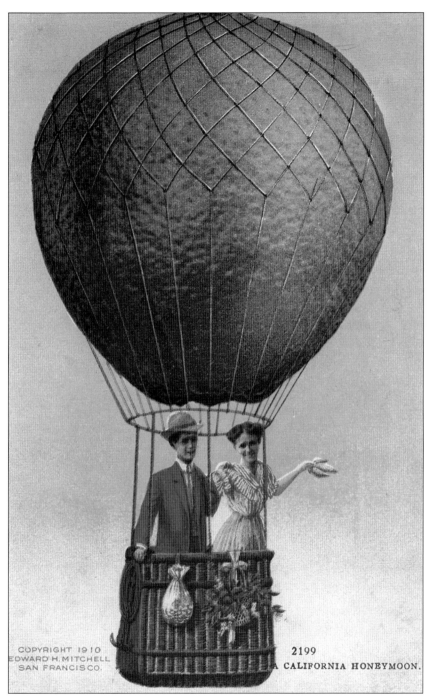

COPYRIGHT 1910
EDWARD H. MITCHELL
SAN FRANCISCO.

2199
A CALIFORNIA HONEYMOON.

Orange-themed postcards, such as this one of "A California Honeymoon," became common in the early 1900s as citrus became one of the county's most important crops. After the refrigerated railroad car was invented in 1890, it became possible to successfully ship the oranges nationwide. Previously unknown on the east coast, the golden fruit soon flooded eastern markets. To coordinate shipping and stabilize prices, county growers formed the California Fruit Growers Exchange in 1893.

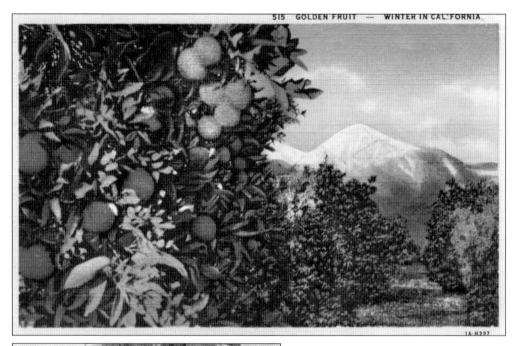

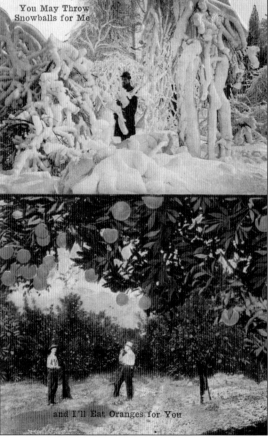

You May Throw Snowballs for Me

and I'll Eat Oranges for You

Navel oranges, introduced to Southern California in the 1880s, revolutionized the orange industry with their ability to produce an almost year-round crop. The image of orange groves blooming in winter with snow covered mountains in the background became an iconic one.

Postcards such as this one were sent by thousands of winter visitors to their snowbound friends and relatives on the east coast. "You may throw snowballs for me and I'll eat oranges for you" was a common caption printed on these postcards.

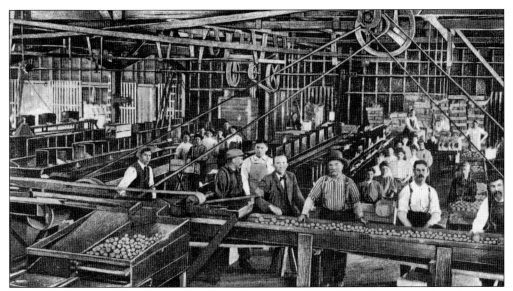

This postcard depicts the interior of an orange packinghouse. As orange groves proliferated, packinghouses appeared throughout the region, usually located near railroad tracks for easy shipment. In a labor intensive process, packinghouse workers sorted, graded, washed, and wrapped the oranges before packing them into shipping crates. Only the highest quality oranges received the label of Sunkist, the trademark of the California Fruit Growers Association. Medium-grade oranges were packed with other labels, and the lowest-grade oranges were made into juice.

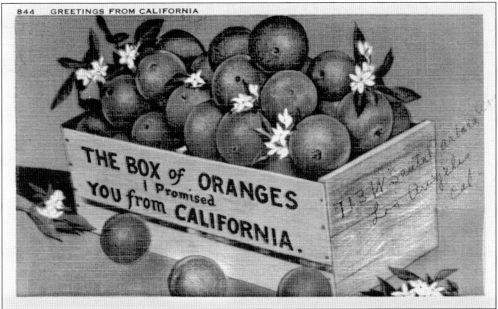

To increase demand for a fruit previously considered a novelty, the California Fruit Growers Association began heavy advertising campaigns. Slogans such as "Oranges for Health- California for Wealth" appeared in the early 1900s, successfully increasing both orange consumption and tourism to the region. The association, with their new Sunkist brand, implemented a "Drink an Orange " campaign in 1916, introducing orange juice, another previously uncommon product, to the American breakfast table.

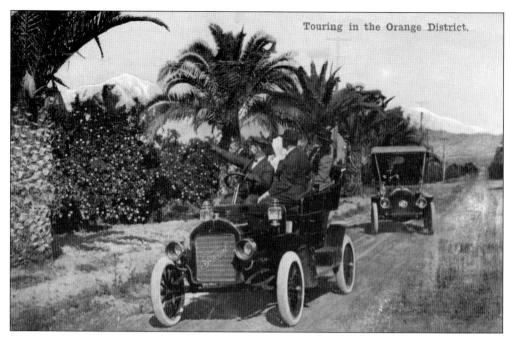

As advertisements flooded the country promoting the oranges grown in Los Angeles County, many tourists couldn't wait to see the groves for themselves. Touring the orange groves found throughout the foothill region became one of the most popular sightseeing activities.

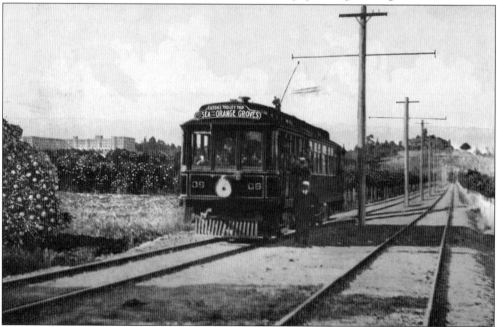

Catering to the tourists who traveled to the region to see the oranges made famous by nationwide advertisements, many of the daylong escorted trolley trips popular in the early 1900s included visits to the orange groves. The Tilton's Trolley Trip car in this 1909 postcard is traveling through the Pasadena area, one of the best-known orange districts. The Hotel Wentworth, later renamed the Huntington Hotel, is visible in the background on the left.

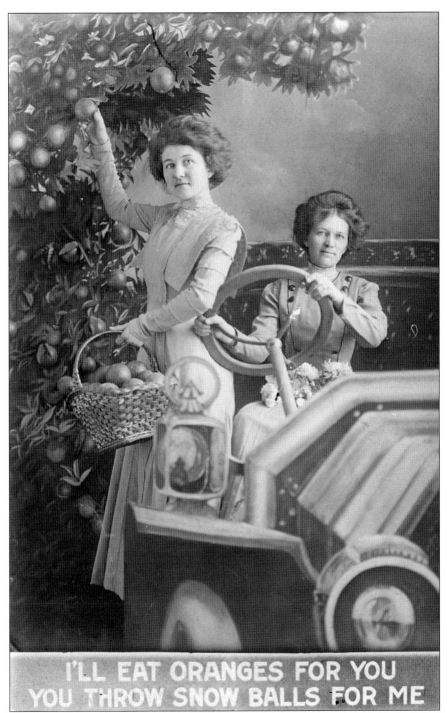

**I'LL EAT ORANGES FOR YOU
YOU THROW SNOW BALLS FOR ME**

Since the orange groves were privately owned, tourists could view them from auto or trolley, but they were not usually able to stop and pick an orange for themselves. Instead, the many visitors who wished to have a souvenir photo of themselves picking oranges resorted to posed studio portraits. The portraits were commonly made into postcards to send home, complete with captions such as the one appearing here: "I'll eat oranges for you. You throw snow balls for me."

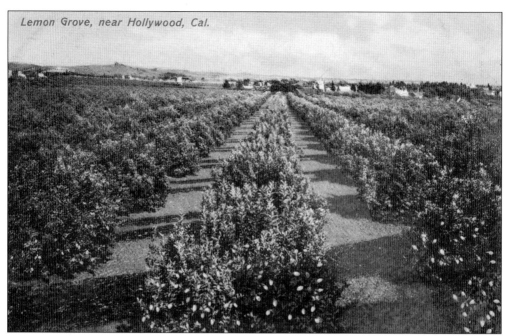

Lemon Grove, near Hollywood, Cal.

This postcard depicts a lemon grove near Hollywood. By the turn of the 20th century, Los Angeles County was one of the nation's leading agricultural producers. The main citrus crop was oranges, but lemons and grapefruit were also grown. Especially in the early days, lemons were a valuable crop, prized because they stayed fresh in transit longer than oranges.

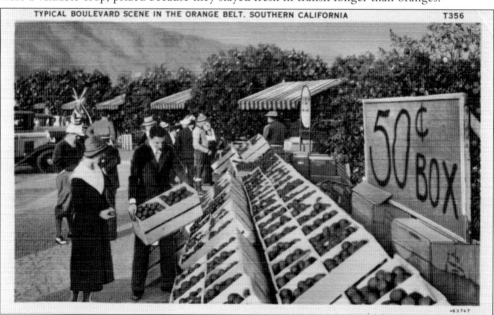

TYPICAL BOULEVARD SCENE IN THE ORANGE BELT, SOUTHERN CALIFORNIA T356

This 1920s postcard depicts visitors purchasing oranges at a roadside stand in the foothill citrus belt. After World War II, citrus began to slip from its position as one of Los Angeles County's top industries. With high demand for new housing, land became more valuable for residential use, and orange groves were plowed under to make way for subdivisions. Once a common sight, orange groves in modern Los Angeles County have all but disappeared.

Two

SMALL TOWN DAYS

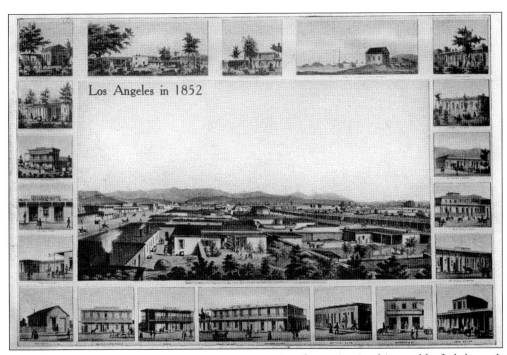

Los Angeles in 1852

Founded as a tiny Spanish settlement in 1781, Los Angeles maintained its pueblo feel through much of the 1800s. Surrounded by enormous ranchos, the small town was the business and social center of the entire region. This early 1900s postcard is a reprint of an 1857 lithograph that depicts the pueblo as it appeared in the 1850s. The border of the image is composed of representations of the town's important businesses and residences. After a transcontinental railroad connection was completed in 1876, the arrival of a host of new residents and tourists set the course of change that would eventually transform the town into the state's most important city.

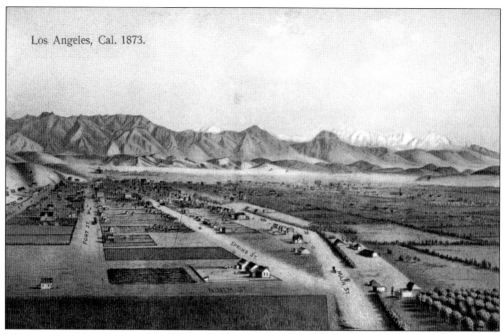

Los Angeles, Cal. 1873.

This postcard depicts Los Angeles in 1873, looking north toward the central residential and business district in the distance. At the time, the sparsely populated portion in the foreground was considered an outlying part of town. The agricultural area to the east of Main Street was planted with some of the county's first vineyards and orange groves.

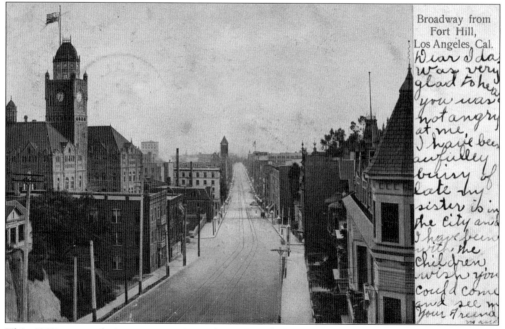

Broadway from Fort Hill, Los Angeles, Cal.

This 1907 postcard pictures a portion of Los Angeles's civic and business center as it appeared at the turn of the 20th century. Facing south on Broadway, the city's two most important civic buildings at the time are visible: the large courthouse in the left foreground, and the city hall, whose spire is visible at the center of the image in the distance.

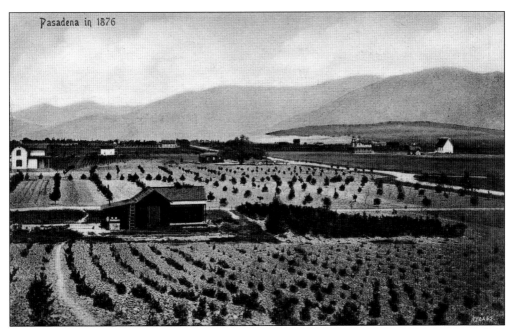

Pasadena in 1876

The California Colony of Indiana, formed in 1873 by a group of Indiana families tired of harsh winters, sent their representative Daniel Berry to Southern California to locate an ideal place to establish a new agricultural community. Berry purchased 4,000 acres in what would become Pasadena, and members of the colony arrived in 1874 to choose their lots. This 1907 postcard depicts Pasadena a few years later in 1876, after the first few homes had been constructed.

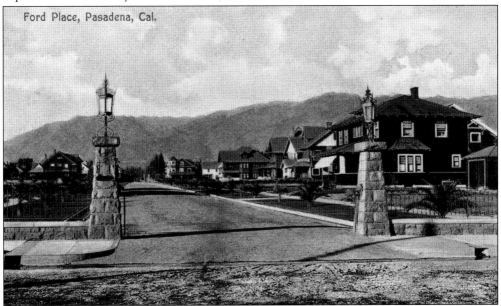

Ford Place, Pasadena, Cal.

This postcard depicts the tree-lined streets and stately homes of Ford Place, an early subdivision in Pasadena. To convince buyers to purchase a lot, developers of new subdivisions such as Ford Place often added improvements such as entrance gates, paved roads, sidewalks, and landscaping. Several of the homes of Ford Place are now part of Pasadena's Fuller Seminary, which uses them for offices and student housing.

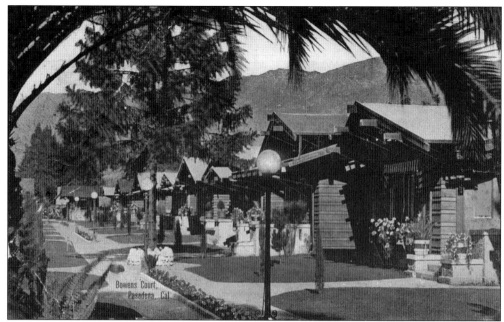

A distinctly Southern California idea, the bungalow court began appearing throughout Los Angeles County in the early 1900s. Devised as a way of grouping several small private residences around a shared landscaped courtyard, the bungalow court was a popular housing solution for those of more modest means. While bungalow courts are now a less common sight, Bowen Court, constructed in 1910 as one of the first examples of the style, remains standing in Pasadena.

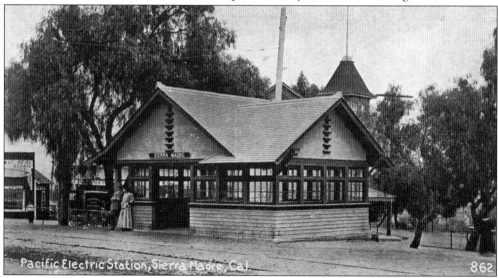

This postcard depicts a Pacific Electric station in the foothill community of Sierra Madre. For the small mostly agricultural towns founded throughout the county in the late 1800s, the arrival of a Pacific Electric line provided a quick and easy way to connect with the business and social center of downtown Los Angeles. The convenient transit option also allowed city residents to move further from downtown, resulting in unprecedented growth for many previously remote communities. The line to Sierra Madre was completed in 1906, setting off a series of new developments in the small town.

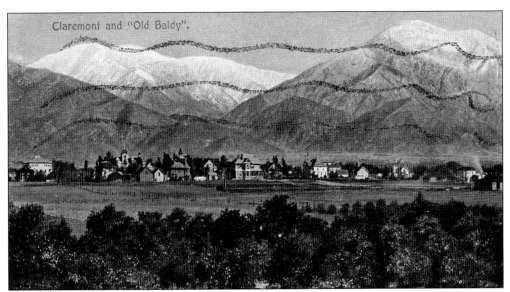

Claremont and "Old Baldy".

Claremont is shown here as it appeared in the early 1900s, set between orange groves and snow-covered Mount Baldy, the highest peak in the county. Claremont was one of several towns laid out along the route of the Santa Fe Railroad in the late 1880s in anticipation of the population boom that would occur when the railroad began service. As with the county's other foothill towns, citrus growing was Claremont's major industry before World War II.

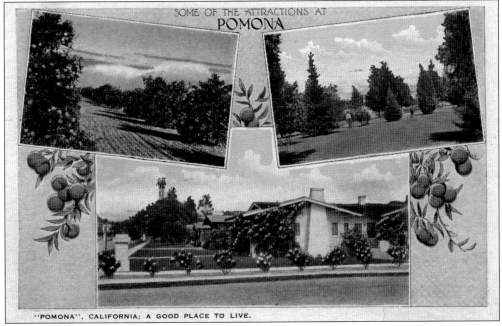

SOME OF THE ATTRACTIONS AT POMONA

"POMONA", CALIFORNIA; A GOOD PLACE TO LIVE.

One of the first towns in the eastern portion of Los Angeles County, Pomona was formed when the Los Angeles Immigrant and Land Co-operative Association purchased several thousand acres of what had been the San Jose Rancho. The association laid out the town site in 1875 and began selling residential lots. Named after the Roman goddess of fruit, Pomona in 1888 became the fifth city in the county to incorporate. By the time of this 1924 postcard, Pomona had become one of the county's leading citrus producers.

27

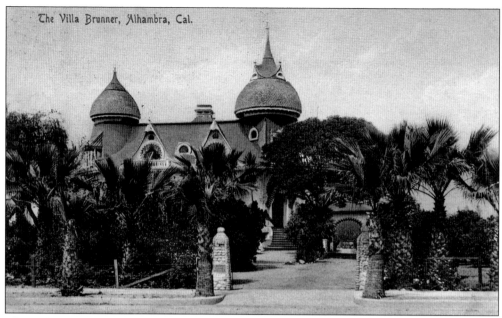

The Villa Brunner, Alhambra, Cal.

The Villa Brunner, a Moorish-style home located on Main Street, was one of Alhambra's most distinctive and best-known early homes. The first settlers arrived in Alhambra in 1874, when Benjamin Wilson subdivided the 275 acres of land he owned. The tract was named Alhambra at the request of Wilson's daughter, who was reading Washington Irving's *The Alhambra* at the time. The new tract gained popularity for being one of the few at the time to have water piped to each lot.

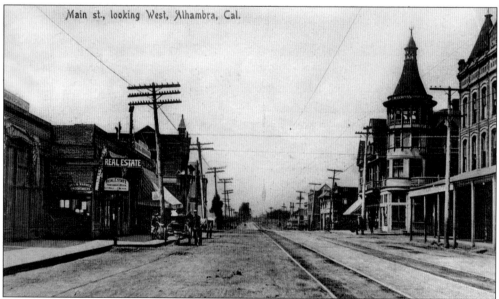

Main st., looking West, Alhambra, Cal.

This postcard depicts the business center of Alhambra near Main Street and Garfield Avenue as it appeared at the turn of the 20th century. The spired structure at right is the Alhambra Hotel, a grand hotel built during the real estate boom years of the mid 1880s. The building was the largest in the area, and the viewing deck on the fourth floor offered an expansive view of the surrounding San Gabriel Valley. The hotel was destroyed by fire in 1908.

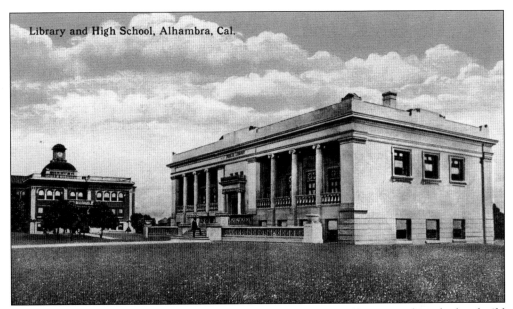

Library and High School, Alhambra, Cal.

After Alhambra became an incorporated town in 1903, civic efforts were launched to build the two structures seen here. Construction on Alhambra High School, left, began in 1905, and the site for the library, right, at Main and Fourth Streets was purchased a few years later. Both landmarks of the young city have since been replaced with larger facilities.

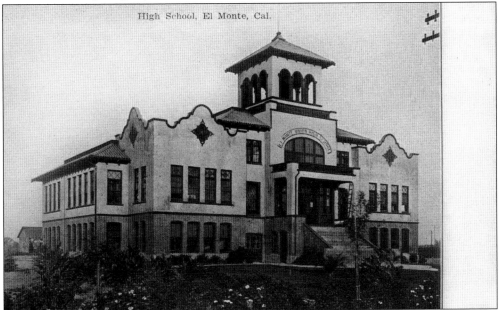

High School, El Monte, Cal.

For residents of the agricultural communities spread throughout the county, the formation of a high school district was a major accomplishment and source of pride. The El Monte Union High School District, formed in 1901, was one of the first in the San Gabriel Valley. Originally meeting in the local grammar school, the high school had an enrollment of less than twenty students, even though classes were open to students from surrounding communities including Whittier, Montebello, and Arcadia. This postcard is postmarked in 1908, the year the district was able to build its own high school campus.

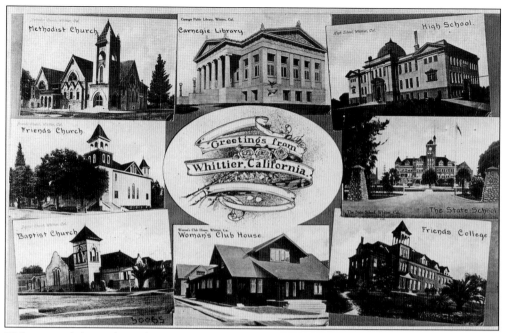

This postcard shows the early community landmarks of Whittier. The town dates to 1887, when a group of Quakers from the East Coast who were interested in forming a California colony purchased 1,200 acres there. Named after Quaker poet John Greenleaf Whittier, the town experienced steady growth after the arrival of a Pacific Electric line in 1904.

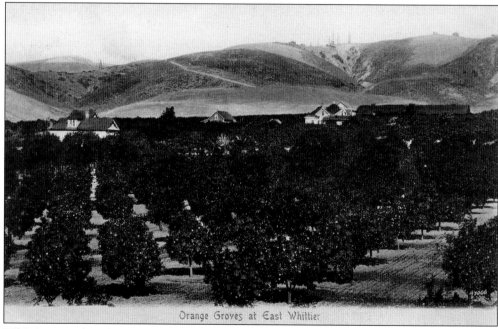

Whittier in its founding years in the late 1800s was primarily an agricultural town, with settlers planting a variety of fruits, grains, and vegetables. By the 1890s, citrus growing had become the town's foremost industry, leading to the formation of the Whittier Citrus Association in 1901. The town was also one of the county's largest producers of walnuts.

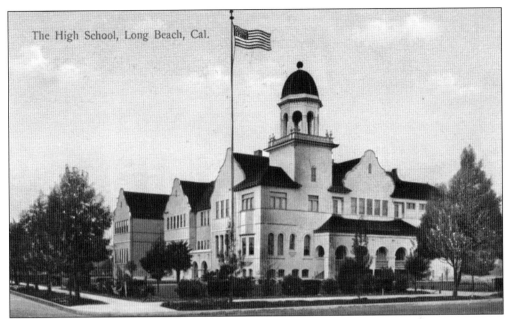

The High School, Long Beach, Cal.

This postcard depicts Long Beach's first high school, opened in 1898 at the corner of Eighth Street and American Avenue, later renamed Long Beach Boulevard. Following the opening of the Pike amusement zone and the arrival of the Pacific Electric line, both in 1902, Long Beach became one of the county's fastest-growing cities. After the larger Long Beach Polytechnic High School opened in 1911 at Sixteenth Street and Atlantic Avenue, the school shown here served as the American Avenue Grammar School until is was destroyed by fire in 1918.

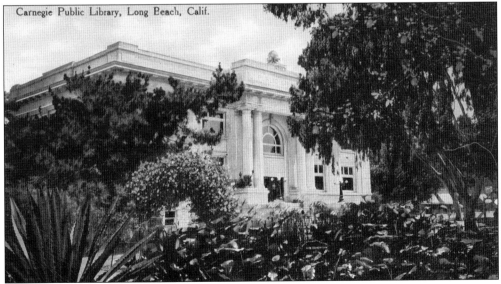

Carnegie Public Library, Long Beach, Calif.

Long Beach's first library, constructed with a Carnegie grant, opened in 1909 at Broadway and Pacific Avenue. Carnegie libraries were found throughout the county in the early 1900s, as the best chance for newly formed towns to raise funds for library construction was to apply for a grant from philanthropist Andrew Carnegie. Often one of a city's first imposing structures, many Carnegie libraries have since been replaced with larger facilities. The library shown here was destroyed by fire in 1974.

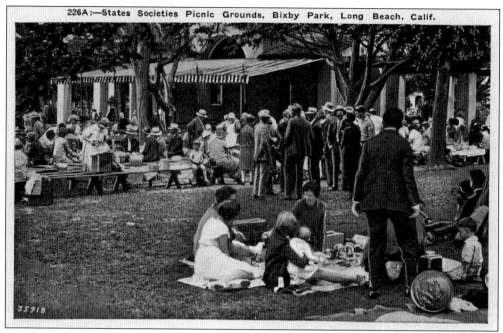

226A:—States Societies Picnic Grounds, Bixby Park, Long Beach, Calif.

This postcard depicts people attending a state society picnic at Bixby Park in Long Beach. Until the 1960s, state picnics occurred annually at various county parks, allowing residents to reconnect and reminisce with others who had migrated from their home state. Iowa was one of the best-represented states at Bixby Park picnics. So many Iowans had settled in Long Beach that for many years the city was referred to as "Iowa by the Sea."

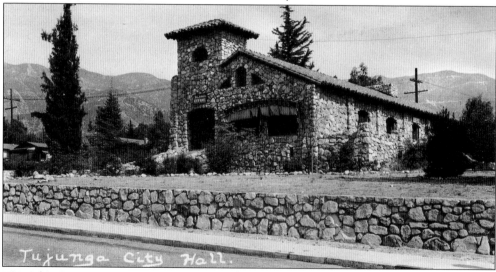

This real photo postcard pictures the building used as Tujunga City Hall for the brief years between Tujunga's incorporation in 1925 and its annexation to the city of Los Angeles in 1932. The building dates to 1913, when it was constructed using local river rock to serve as a community center for the short lived utopian society that had settled there in 1907. Known as the Little Landers, the group followed the principles of cooperative farming under the slogan "A Little Land and a Lot of Living." Today known as Bolton Hall, the building is used as a museum for the Little Landers Historical Society.

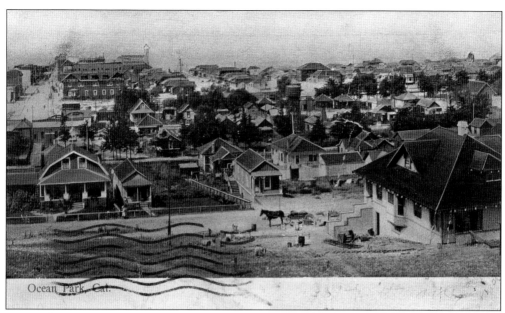

Postmarked in 1905, the postcard above depicts some of the small homes constructed by the first buyers in the resort town of Ocean Park. Abbot Kinney and Francis Ryan purchased the beachfront property in 1891, and convinced the Santa Fe Railroad to extend a line there in 1892. As the first lots went for sale, visitors began flocking to the new pier and beach amusements. Abbot Kinney gave up his interest in Ocean Park in 1904 in exchange for the undeveloped property to the south, where he constructed his dream city, Venice of America, in 1905. Though the beachfront area and pier were designed as a tourist attraction, residential lots were laid out along Venice's canals and a small community soon developed. The postcard below depicts the cottages along one of Venice's early streets. Ocean Park and Venice both incorporated in 1904, although Ocean Park changed its name in 1911 to become part of Venice. While it maintains its distinct identity, Venice has been part of the city of Los Angeles since 1925.

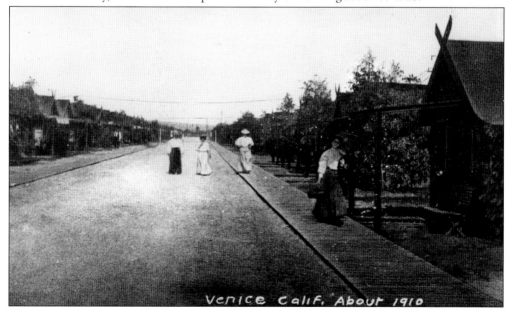

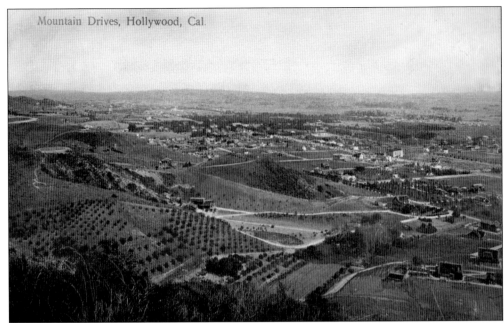

Mountain Drives, Hollywood, Cal.

This pre-1910 postcard overlooks early Hollywood, founded by Kansas prohibitionists Horace Wilcox and his wife when they subdivided their ranch holdings in 1887. Before the arrival of the first movie studios in the 1910s, Hollywood was a small quiet town of citrus groves and pleasant homes. The town was incorporated briefly from 1903 to 1910, when residents voted in favor of annexation to the city of Los Angeles.

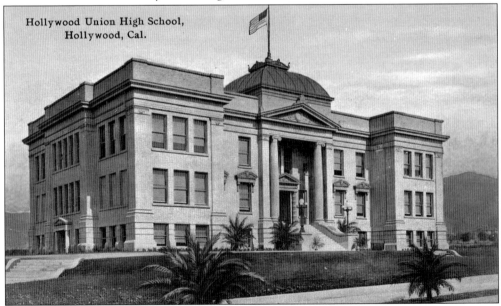

Hollywood Union High School, Hollywood, Cal.

The Hollywood Union High School District was formed shortly after Hollywood incorporated in 1903. The cornerstone for the city's first high school, located at Highland Avenue and Sunset Boulevard, was laid the following year. The school continued to operate as part of the Los Angeles school district after Hollywood was annexed in 1910. Hollywood High School's current campus was constructed in 1933 on the site of the first school campus, shown here.

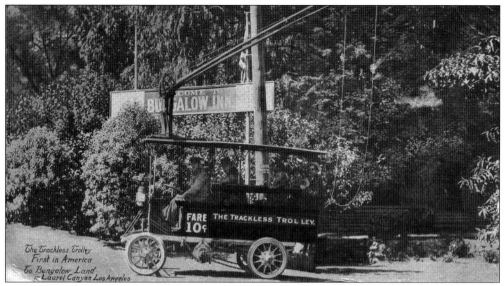

The trackless trolley seen in this postcard was built around 1910 by Charles Mann as a way to promote and bring prospective buyers to the Laurel Canyon development he called Bungalow Land. The Bungalow Inn was constructed as a rest stop for those making the trolley journey. Mann also constructed Lookout Mountain Inn at the top of Lookout Mountain, overlooking Hollywood, as another attempt to bring buyers to the new development. The first of its kind in the country, the trackless trolley only operated for a few years. The hillside lots of the Bungalow Land development, originally marketed as mountainside vacation lots, soon became home to permanent residents.

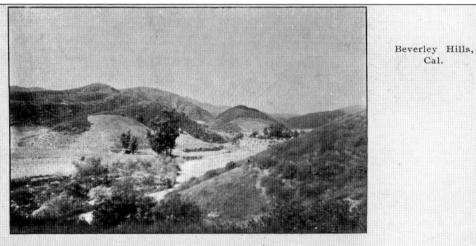

Subdivided in 1906 by the Rodeo Land and Water Company, Beverly Hills is pictured here shortly before being developed into the "finest residence section in Southern California." Naming the new development after Beverly Farms in Massachusetts, president Burton Green hoped to create a fine residential community of tree-lined streets winding along the natural contours of the hills. After Hollywood's favorite movie stars Mary Pickford and Douglas Fairbanks constructed a home there, Beverly Hills became a celebrity enclave.

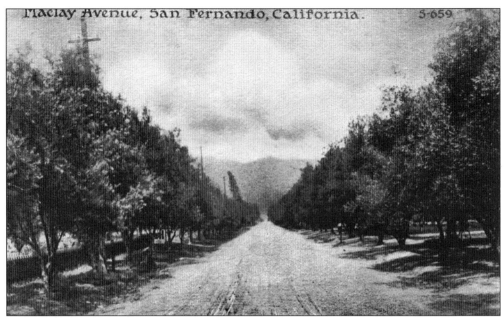

Maclay Avenue, San Fernando, California. 5-659

The first city in the San Fernando Valley, San Fernando was founded in 1874 by Charles Maclay. This early view depicts the tree-lined street near the old San Fernando Mission named after Maclay. Unlike surrounding communities that struggled to find water before the Los Angeles Aqueduct was completed in 1913, San Fernando had a steady supply of well water, allowing it to become a successful agricultural community.

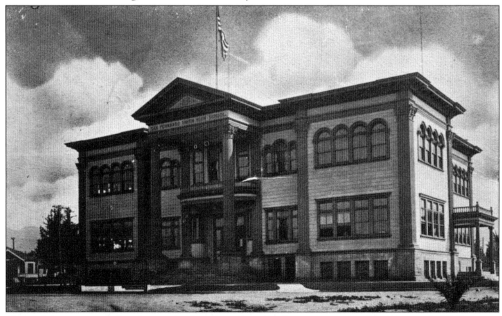

One of the most productive agricultural regions in the county, the San Fernando Valley was known for its citrus crops, olives, and grain. Shown here is one of the oldest schools in the San Fernando Valley, San Fernando High School, which was established in 1896 to serve the students of the agricultural town. Originally located at Fifth and Hager Streets, the high school moved in 1906 to the site on North Brand Boulevard that it would occupy until 1952.

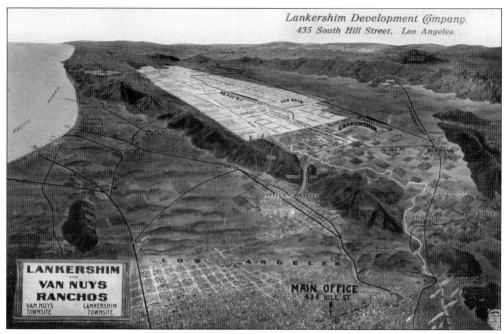

This postcard overlooks the town sites of Lankershim and Van Nuys. The San Fernando Homestead Association, formed by Isaac Van Nuys and Isaac Lankershim in 1869, once owned much of the San Fernando Valley. In 1880, Van Nuys and Lankershim's son James founded the Los Angeles Farming and Milling Company, establishing grain as one of the valley's major crops. In response to the land boom of the 1880s, James Lankershim established the town of Lankershim, now known as North Hollywood. When construction on the Los Angeles Aqueduct began, several new town sites were laid out in the San Fernando Valley in anticipation of the population increase that would occur once water was readily available. The towns of Marion, now Reseda, and Owensmouth, now Canoga Park, were established, and in 1911 the first lots went for sale in Van Nuys. After the aqueduct opened in 1913, much of the San Fernando Valley voted to be annexed to the city of Los Angeles in order to receive their share of the water.

After the Santa Fe Railroad constructed their track through the Antelope Valley in 1876, connecting Los Angeles to San Francisco, settlers began arriving and establishing farms there. Relying first on artesian wells such as the one shown here, farmers began installing irrigation systems after a serious drought in the 1890s. After water from the Los Angeles Aqueduct arrived, the Antelope Valley became an agricultural center, with alfalfa as one of the top crops.

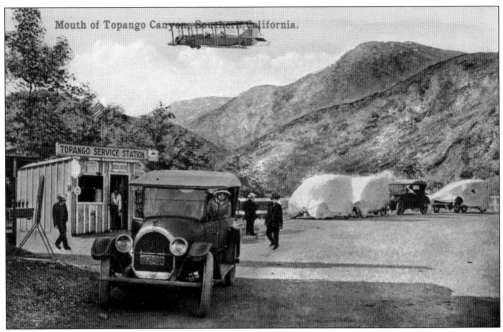

This postcard depicts an early service station and cars along the highway in Topanga, a community in the Santa Monica Mountains. First settled in the late 1800s, Topanga had by the 1920s become popular among celebrities for the seclusion and privacy offered in the scenic canyon.

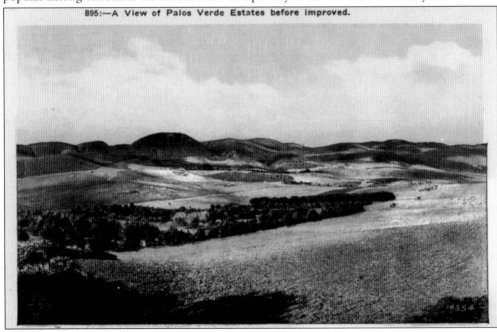

Palos Verdes Estates, shown here before any development has occurred, was one of Los Angeles County's first master planned communities. Naming their development the Palos Verdes Project, the group of investors who acquired the land in 1913 envisioned a scenic residential community of large estates. Hallmark features of the town were completed throughout the 1920s and 1930s, including the La Venta Inn, the golf course, swimming club, parks, and extensive landscaping.

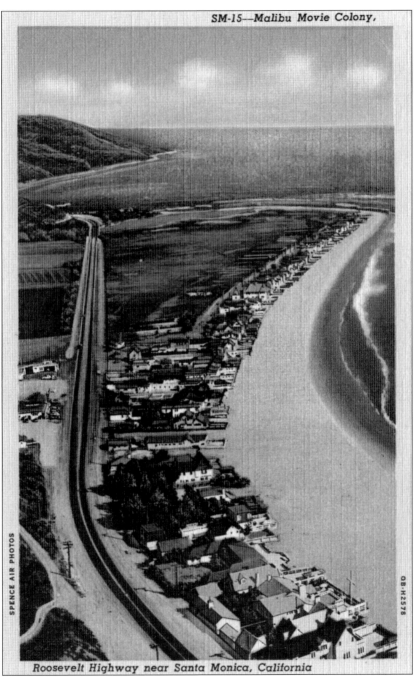

SM-15—Malibu Movie Colony,

SPENCE AIR PHOTOS

QB-H2578

Roosevelt Highway near Santa Monica, California

Rancho Malibu, the last of the county's ranchos to remain intact and privately owned, was purchased in 1892 by its final owners Frederick and May Rindge. After Frederick died in 1905, May Rindge continued the ranch's cattle and grain raising operations. The 17,000-acre ranch was kept in isolation until court cases in the 1920s forced Rindge to allow the state to build a highway along the coast. The Roosevelt Highway, now Pacific Coast Highway, opened in 1929. The famed Malibu movie colony was born in 1926, when Rindge began leasing beach lots to movie stars in order to raise funds to pay her legal fees.

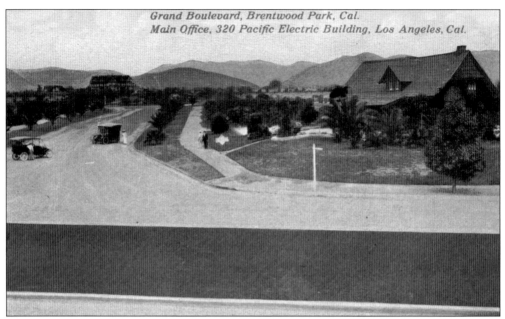

Grand Boulevard, Brentwood Park, Cal.
Main Office, 320 Pacific Electric Building, Los Angeles, Cal.

This early advertising postcard pictures the residential community of Brentwood Park, subdivided in 1906. Located west of Los Angeles on the edge of Santa Monica Canyon, the new subdivision was promoted as a scenic, quality neighborhood, far from urban bustle yet still convenient to the city via Pacific Electric line. After annexation to the city of Los Angeles in 1916, many of the subdivision's landscaped winding roads were straightened and renamed. Grand Boulevard, shown here, is now Bristol Avenue.

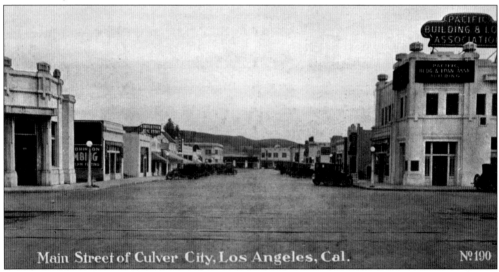

Main Street of Culver City, Los Angeles, Cal. № 190

This postcard depicts an early view of Culver City's business center. Culver City was created in 1913 when Harry Culver selected a site halfway between downtown Los Angeles and Venice that he felt would be ideal for a city. With ads proclaiming that "All roads lead to Culver City," Culver hoped to create a city with a balance of residential and commercial activities. Shortly before the city incorporated in 1917, Culver convinced Thomas Ince to relocate his Inceville Studios to the new town. Other studios followed, and by the 1920s the city had become known as a center for movie production.

When developers Amos Burbank and Eugene Baker first subdivided the city that is now Huntington Park in 1901, they named their development La Park. To encourage Henry Huntington to extend a Pacific Electric line there, Burbank and Baker decided not only to offer a right of way, but also to rename the town in Huntington's honor. Though Burbank and Baker envisioned the city as a commercial center and opposed official township, citizen efforts prevailed, and the city was incorporated in 1906.

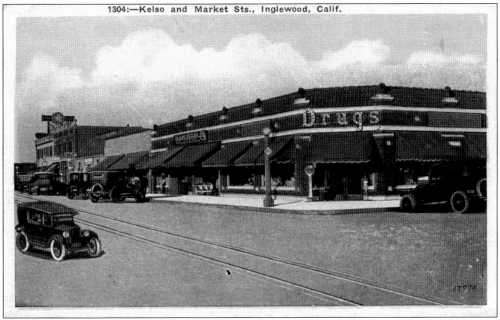

This 1920s postcard depicts a portion of the early business district in Inglewood at the intersection of Kelso and Market Streets. Formed in 1888, Inglewood was the first town in the area, located on lands once part of the Centinella Rancho. Originally an agricultural community, post–World War II industry and the growth of Los Angeles International Airport, founded as Mines Field in 1927, transformed the town.

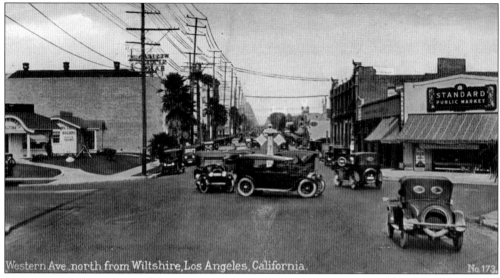

Western Ave., north from Wiltshire, Los Angeles, California. No. 173.

This postcard shows some of the early small businesses at the intersection of Wilshire Boulevard and Western Avenue. Later to become one of the city's busiest thoroughfares, stretching from downtown Los Angeles to Santa Monica, Wilshire Boulevard began as a four-block path in 1895. In a part of town then considered far from the city center, the original four-block boulevard was designed to help attract buyers to the exclusive residential subdivision developed by Henry Gaylord Wilshire. As cars gained popularity, businesses began locating along the boulevard, which began to change from a neighborhood of family estates into a booming shopping district.

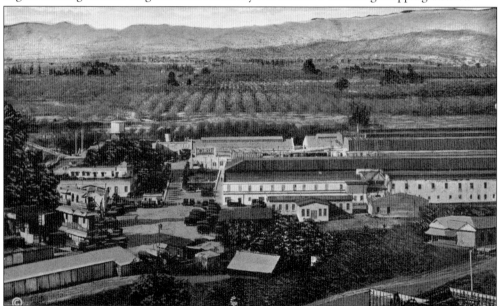

The community of Universal City has its roots in the 200-acre Universal City Studio opened by Carl Laemmle in 1915. Surrounded by ranch lands, Laemmle constructed an entire "city" devoted to making movies, inviting spectators to watch the entire production. Streets, bungalows, and later a zoo and a post office were added as the successful movie making community began developing into a real town. Although the studio was closed to the public when sound pictures were introduced, the surrounding town continued to prosper.

Three

ATTRACTIONS

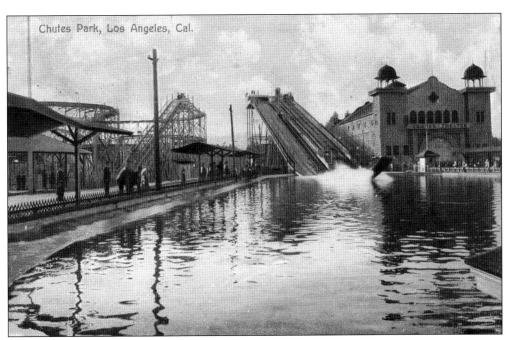

Chutes Park, Los Angeles, Cal.

This 1908 postcard shows Chute's Park, Los Angeles's earliest amusement park. Located at Washington and Main Streets, at the time on the outskirts of the downtown area, the popular attraction operated under various owners and names from 1887 to 1914. The park featured a roller coaster, a Shoot the Chutes boat ride, a theater, a miniature railway, animal exhibits, and venues for dining and dancing.

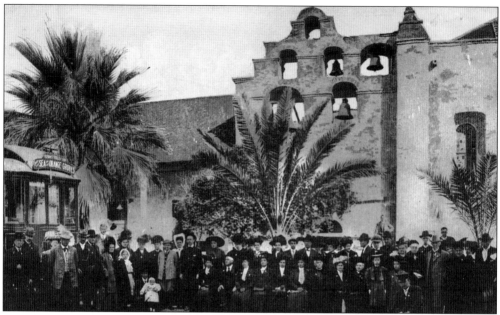

This 1909 postcard depicts tourists posed in front of the San Gabriel Mission with their Tilton's Trolley Trip car. The mission had become a must-see tourist destination after popular novels of the day, such as Helen Hunt Jackson's 1884 bestseller *Ramona*, had helped spread romantic notions of the Spanish mission days. Tilton's popular 100-mile, daylong trolley trip visited Pasadena and the orange groves in the morning, made a stop at the mission, and then continued to spend the afternoon exploring the beach cities.

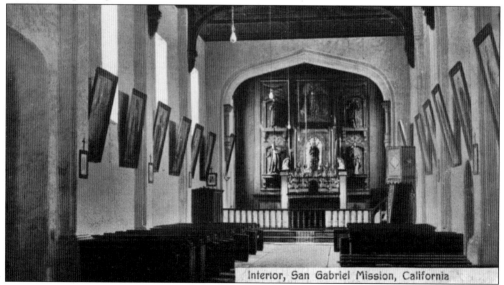

Interior, San Gabriel Mission, California

Shown in this postcard is the interior of the church at the San Gabriel Mission. Founded in 1771, the mission moved to its present San Gabriel location in 1776. The fourth in a chain of 21 missions throughout Southern California, the San Gabriel Mission became one of the largest and most prosperous. Covering at its height over a million acres from the mountains to the sea, the mission's lands were roamed by tens of thousands of cattle and planted with the region's earliest orchards and vineyards.

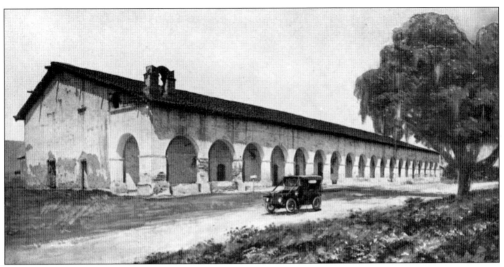

Founded in 1797, the San Fernando Mission was California's 17th mission. Located on the main road leading to and from Los Angeles in the early days, the mission's expansive lands were used for cattle grazing, orchards, and vineyards. At the time of this early 1900s postcard, the San Fernando Valley was still relatively rural, and the mission had fallen into severe disrepair. Though never as popular as the San Gabriel Mission, many early auto enthusiasts embarked on a day trip to enjoy the country drive and visit the ruined buildings. Today located near busy Sepulveda Boulevard, the San Fernando Mission was finally restored and opened to visitors in 1940.

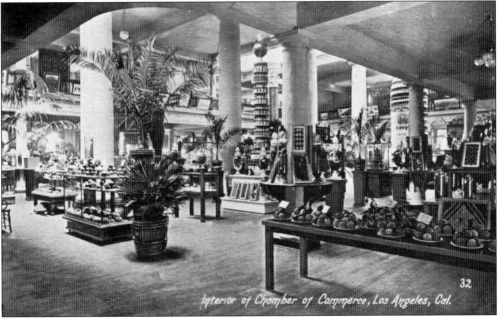

A popular stop for tourists in the early 1900s, the Chamber of Commerce Building in downtown Los Angeles contained two stories of exhibit space. Formed to promote the Los Angeles region, the Los Angeles Chamber of Commerce set up exhibits to showcase the county's attributes, focusing especially on artistic displays of the region's famed fruit and agricultural products. Exhibits of items relating to Southern California history, including numerous relics of the Spanish mission days, were also popular.

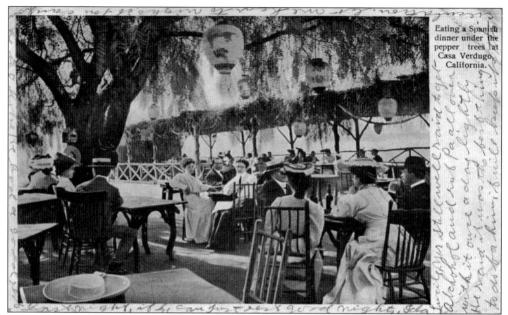

Postmarked in 1906, this postcard shows guests enjoying the pepper-tree-shaded patio of the Casa Verdugo restaurant about a year after its opening. Housed in a 100-year-old adobe at Mountain Avenue and Brand Boulevard, the restaurant was established to provide a tourist destination at the end of the new Pacific Electric line extending up Brand Boulevard into the undeveloped north Glendale area. After the scenic ride from downtown Los Angeles, visitors enjoyed a Mexican-style meal along with music and entertainment.

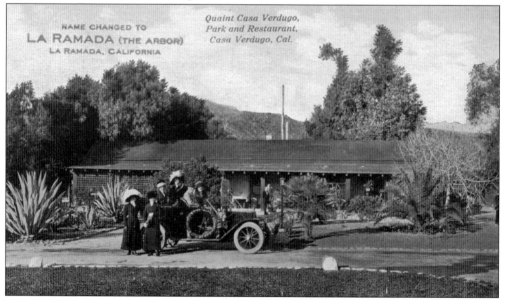

This postcard shows a carful of tourists outside the Casa Verdugo restaurant. At the time in a remote area, the popular restaurant was designed to provide a romantic experience recreating the days of early California. After moving to a newer adobe nearby, the restaurant spent its final years in the 1920s at its third and final location, a mission-style building at Randolph and Louise Streets, now a private residence.

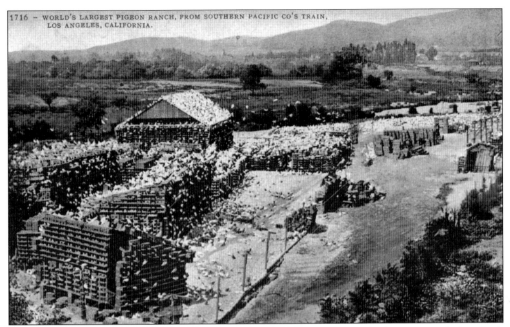

This 1919 postcard depicts the Los Angeles Pigeon Ranch. Located adjacent to Elysian Park and the then free flowing Los Angeles River, the pigeon farm was the largest of its kind in the world. Visitors to the farm observed the free flying birds from an enclosed viewing area. The pigeon farm washed away in a flood in the 1930s and was never rebuilt.

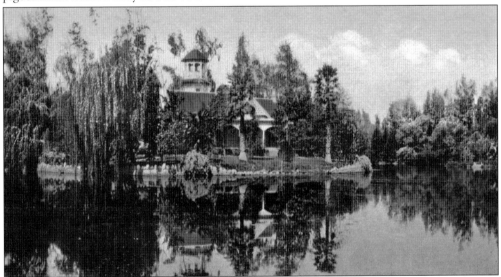

After purchasing 8,000 acres of the former Rancho Santa Anita in 1875, Elias Jackson "Lucky" Baldwin began turning his new ranch into a regional agricultural showplace and a popular tourist destination. Baldwin planted extensive vineyards and hundreds of acres of citrus trees and grain, and also constructed several buildings, including the Queen Anne–style guest house seen here on the edge of the ranch's natural lake. While most of the land was sold over the years to create residential subdivisions, the 111 acres that remained of the ranch, including the guest house and lake, were purchased in 1947 to create the Los Angeles County Arboretum and Botanic Garden in Arcadia.

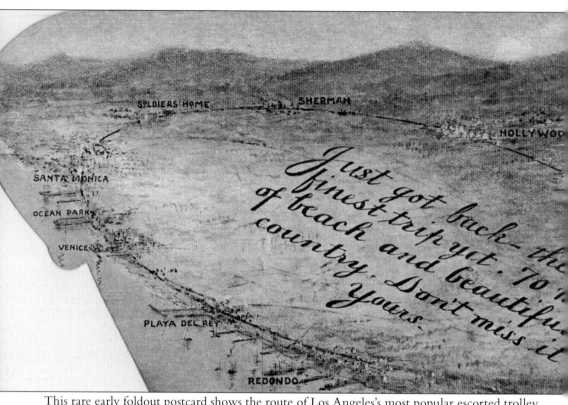

SPLDIERS HOME SHERMAN HOLLYWOD

SANTA MONICA

OCEAN PARK

VENICE

PLAYA DEL REY

REDONDO

Just got back – the finest trip yet. 70 of beach and beautiful country. Don't miss it Yours

This rare early foldout postcard shows the route of Los Angeles's most popular escorted trolley trip, the Balloon Route Excursion. Few visitors to the city missed the heavily advertised trip, which featured the slogans "Not up in the air but down on the earth" and "The only way to see it all and see it right." Operated in the early 1900s first by the Los Angeles Pacific Railway and later by the Pacific Electric, the all-day trip traveled over 100 miles, including over 30 miles along the beach, for only $1. Leaving from downtown Los Angeles, the first stop was in scenic

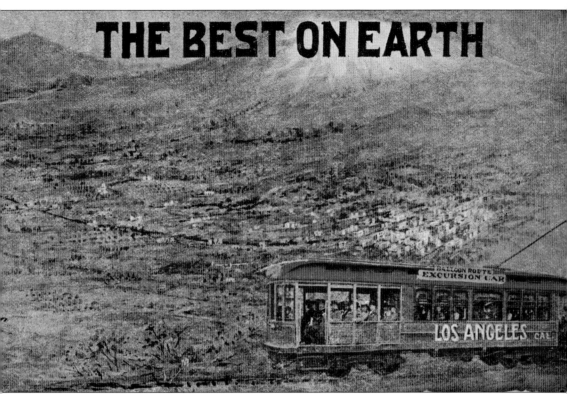

THE BEST ON EARTH

Hollywood for a visit to the home of famed floral painter Paul de Longpre. The trip continued to the Old Soldier's Home in Sawtelle, then on to the beach at Santa Monica before stopping for lunch in Playa del Rey. After the next stop at Redondo Beach's famous moonstone beach, the tour traveled back up the coast, allowing excursionists to spend time exploring the Ocean Park and Venice of America resorts before returning to downtown Los Angeles.

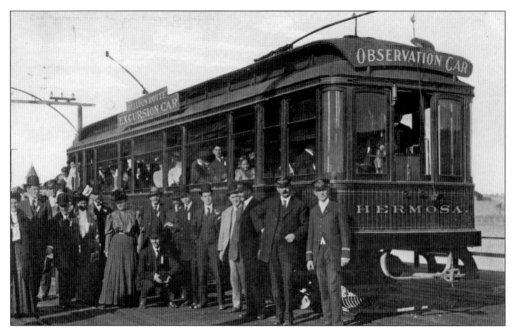

This 1904 postcard depicts a group of tourists with their Balloon Route Excursion car. Offering the advantage of visiting a variety of attractions throughout the region for one low price, daylong escorted trolley tours were a popular activity for visitors to Los Angeles County in the early 1900s. Though the Balloon Route Excursion was one of the most well known, several other trips were available. Popular destinations included the orange growing districts of Pasadena, the San Gabriel Mission, Hollywood, Cawston's Ostrich Farm, Baldwin's Ranch, and the beach cities.

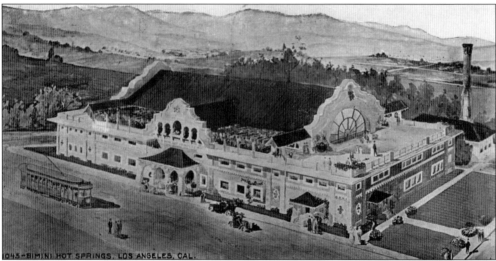

Popular for its reputed health benefits, Bimini Hot Springs was one of several natural hot springs found throughout the county in the early 1900s. This postcard, postmarked in 1917, depicts the Bimini Hot Springs Bathhouse, which was constructed in 1906 after an earlier bathhouse had burned there in 1905. The huge mission-style building, easily accessible by streetcar from downtown Los Angeles, contained 500 dressing rooms, three indoor pools, a gymnasium, and a café. The water was also bottled for drinking and pumped across the street to the Bimini Hotel. The baths eventually went out of business, and the bathhouse was demolished in 1956.

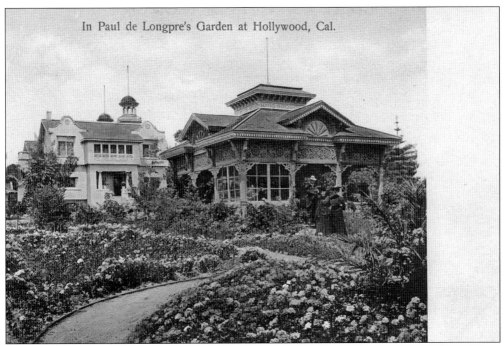

In Paul de Longpre's Garden at Hollywood, Cal.

The home and gardens of French painter Paul de Longpre were located at what is now the corner of Hollywood and Cahuenga Boulevards. Constructed in 1901, several years before the arrival of the first movie studios, de Longpre's estate was rural Hollywood's primary tourist attraction.

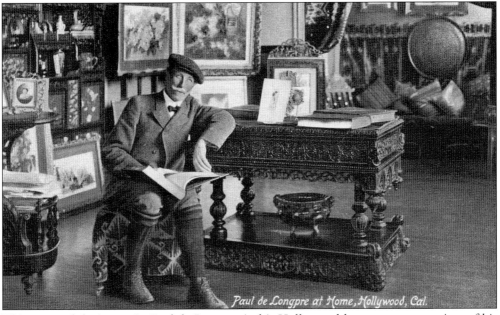

Paul de Longpre at Home, Hollywood, Cal.

This postcard depicts artist Paul de Longpre in his Hollywood home among a variety of his famed floral paintings. The three-acre gardens surrounding his home supplied the subjects for his paintings, and were also open to the public. De Longpre's home was demolished shortly after his death in 1911, just as the newly arrived movie industry began to permanently transform the small agricultural community.

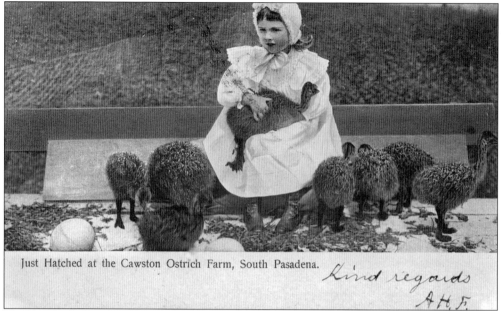

Just Hatched at the Cawston Ostrich Farm, South Pasadena. *Kind regards A.H.F.*

Postmarked in 1906, this postcard pictures a young girl visiting with the baby ostriches at Cawston's Ostrich Farm. Opened by Edwin Cawston in 1896, the South Pasadena farm was one of early Los Angeles's most renowned attractions. The park grounds contained not only ostrich exhibits, but also the Cawston manufacturing plant, where ostrich feathers were transformed into boas, hats, fans, and other accessories popular at the time. With several salesrooms and a huge mail-order department, Cawston's ostrich feather products were known throughout the country.

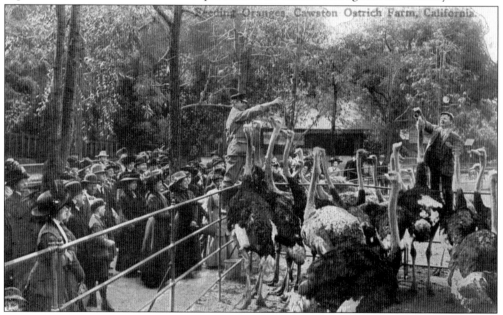

Ostrich feeding time at Cawston's Ostrich Farm was one of the most popular events at the park. Ostriches were fed whole oranges so that guests could delight at watching the round shape glide down the giant bird's long neck. Cawston's popularity waned as ostrich feathers began to fall out of fashion, and the park, unable to weather the Depression, finally closed in 1935.

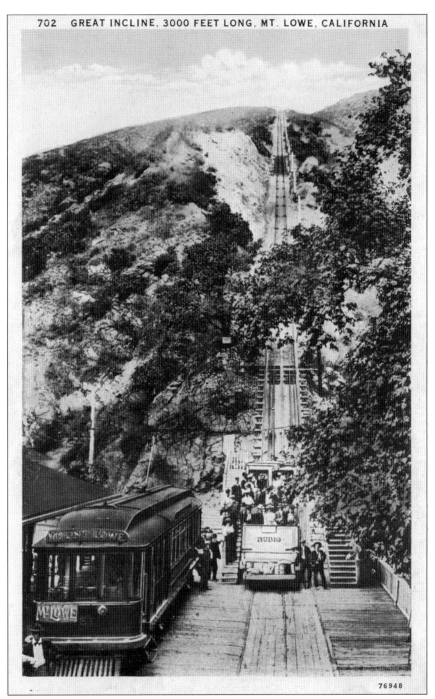

76948

In the early 1900s, no trip to the Los Angeles area would have been complete without experiencing the famed Mount Lowe excursion. After arriving by trolley to the base of Echo Mountain in Pasadena, the journey began with an ascent up the 3,000-foot incline pictured here. Considered an engineering marvel of the time, the incline, built by Thaddeus S. C. Lowe, began operation in 1893. The attractions at the top of the incline included a resort hotel called the Echo Mountain House, a casino for social gatherings, a zoo, and an observatory.

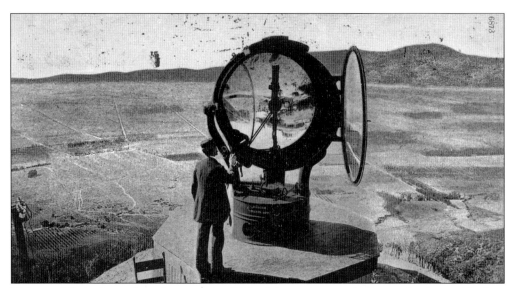

This searchlight, located on the summit of Echo Mountain, was the largest in the world when Thaddeus Lowe purchased it following its debut at the 1893 World's Columbian Exposition in Chicago. As is evident in this postcard, visitors to Echo Mountain enjoyed an impressive view of the entire Los Angeles area. Unfortunately, the attractions on Echo Mountain did not last long: Echo Mountain House burned in 1900, and a 1905 storm destroyed all the other buildings except for the observatory. The searchlight, visible up to 150 miles away when lit, was relocated to the top of the new powerhouse built on the summit after the 1905 storm.

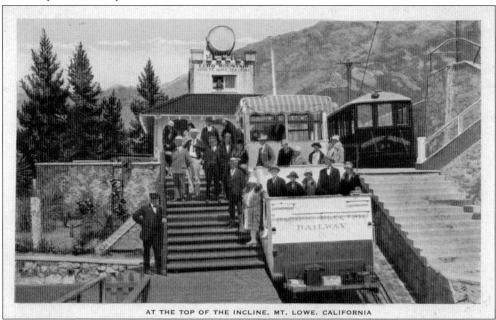

AT THE TOP OF THE INCLINE, MT. LOWE, CALIFORNIA

This 1920s postcard depicts visitors arriving at the terminus of the cable incline. The Mount Lowe excursion had been operated by Pacific Electric since 1902, when Lowe had been forced to sell due to financial troubles. Following the 1905 storm that had destroyed most of the buildings at the top of the incline, Echo Mountain's summit became merely a transfer point for passengers continuing on to the Alpine Tavern, a lodge located further into the mountains.

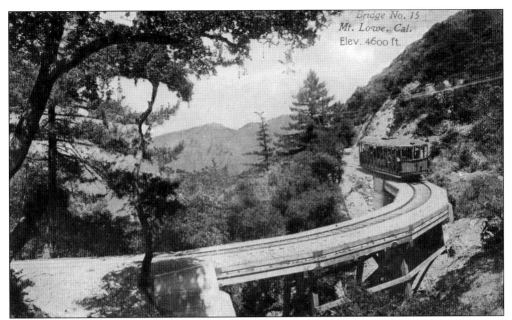

Once visitors arrived at the summit of Echo Mountain, they boarded a narrow-gauge railway car for their three-and-a-half-mile mountain journey along the Alpine Division. Constructed beginning in 1894, the Alpine Division wound over numerous treacherous mountain curves, with some bridges passing over 1,000-foot drops. Visitors, however, enjoyed the 35-minute ride for its rustic scenery and panoramic mountain views.

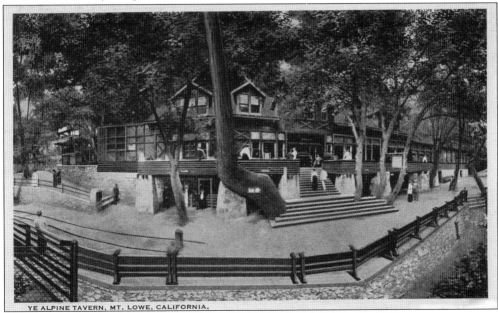

YE ALPINE TAVERN, MT. LOWE, CALIFORNIA.

At the end of the Alpine Division ride, Mount Lowe visitors arrived at the Alpine Tavern, a Swiss-style mountain inn constructed in 1895. As a mountain retreat easily accessible to city residents, the tavern was a popular destination for day trips. Visitors could hike, ride horses, or simply enjoy lunch at the inn. The Alpine Tavern was destroyed by fire in 1936, and Pacific Electric, lacking the funds to rebuild, dismantled both the cable incline and the Alpine Division tracks.

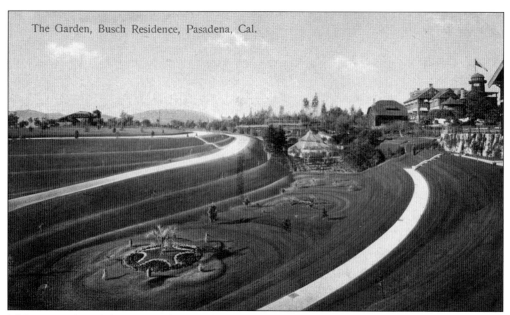

The Garden, Busch Residence, Pasadena, Cal.

This postcard provides a view of some of the terraced gardens at Busch Gardens, one of Pasadena's most-loved tourist destinations in the early 1900s. The gardens were developed over several acres of the Arroyo Seco by Adolphus Busch, cofounder of the Anheuser-Busch brewery. After constructing a winter home for his family on Orange Grove Avenue, Busch began landscaping the gardens, which he opened to the public in 1905. Visitors strolled along the numerous walkways and rustic bridges to enjoy the beautiful scenery, fountains, and fairytale sculptures Busch imported from Germany.

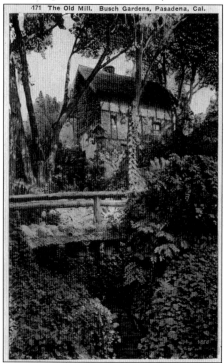

171 The Old Mill, Busch Gardens, Pasadena, Cal.

The Old Mill, a replica of a fairytale house constructed by Adolphus Busch, was a favorite site for visitors to Busch Gardens. Despite their popularity, the gardens were closed in 1938. Due to the high maintenance costs it would entail, the city of Pasadena was unable to accept the family's offer to donate them as a public park, and the land was sold to private developers. Though much has disappeared, the Old Mill still stands as a private residence, and several components of the gardens, including some of the bridges, fountains, and pergolas, remain intact in local backyards.

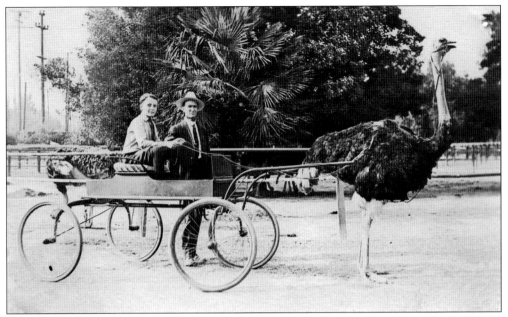

The Los Angeles Ostrich Farm, located on Mission Road across from Eastlake Park, was opened by Francis Earnest in 1906. Visitors delighted in posing with the giant birds for souvenir photographs, such as this one from 1919. The images were often made into postcards to be sent home to friends and relatives. One of the most popular attractions at the farm was the racetrack, where ostrich riding and racing exhibits could be observed.

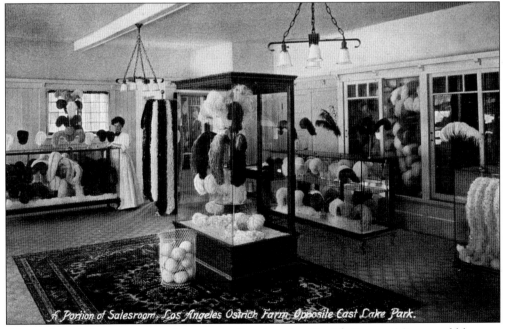

After a day of viewing the ostriches at the Los Angeles Ostrich Farm, visitors could browse at the farm's salesroom. Here fashion conscious women could choose from a large selection of the ostrich feather accessories, including boas, hat feathers, and fans, that were popular in the early 1900s.

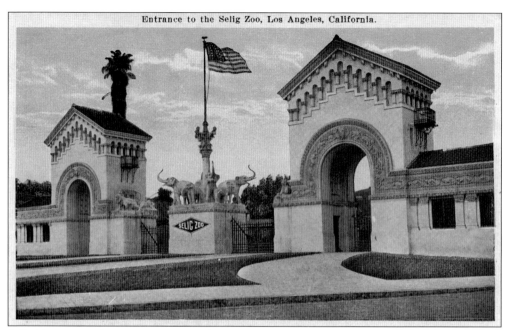

Selig Zoo, opened in 1911, was one of several amusements located around Eastlake Park, now known as Lincoln Park. Founded by filmmaker William Selig, head of the Selig Polyscope Company, the zoo exhibited over 700 animals. The zoo grounds were also the site of all Selig's filming operations, and the animals appeared as frequent stars. Although the studio folded in the 1920s, the zoo continued to operate under a variety of names until the 1930s.

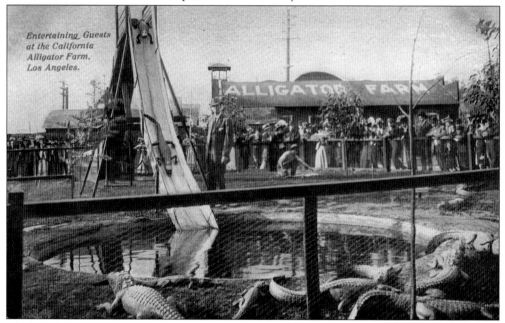

The Alligator Farm was opened across from Eastlake Park by Francis Earnest and Joe Campell in 1907, a year after Earnest had opened the adjacent Los Angeles Ostrich Farm. This postcard depicts one of the most popular shows at the Alligator Farm. Known as "shooting the chutes," a trained alligator would ascend a ramp, and then slide down into the pool of water below.

58

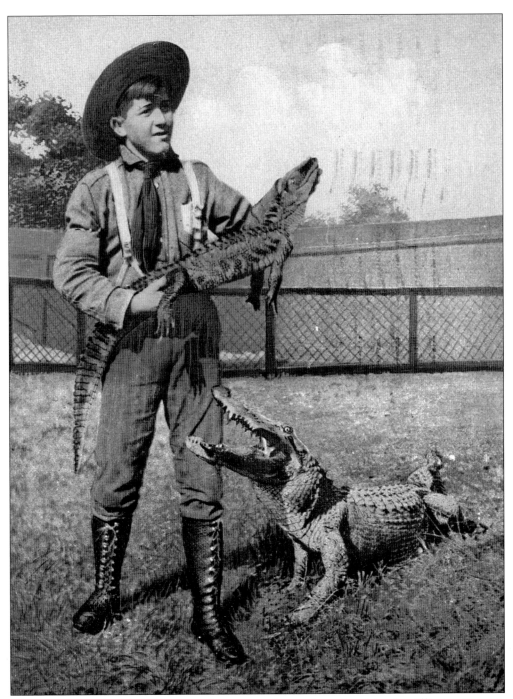

The trainer seen in this 1920 postcard was one of several employed by the Alligator Farm to provide guests with demonstrations and information about alligator life. Hundreds of alligators of all sizes were displayed throughout the park's scenic series of pens and miniature lakes. The park also featured a salesroom where visitors could purchase genuine alligator purses, belts, and other souvenirs. The Alligator Farm closed its Eastlake Park location in 1953 and relocated to Buena Park, where it continued to operate until 1986.

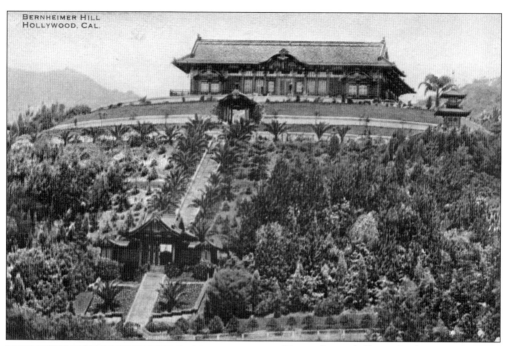

Situated on a hill overlooking Hollywood, the Bernheimer residence was constructed by brothers Adolph and Eugene Bernheimer in 1914. A replica of a Japanese palace, the residence contained the brothers' priceless collection of Asian art.

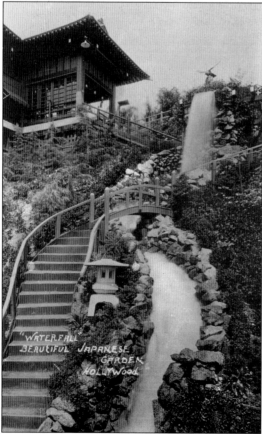

This real photo postcard shows a portion of the carefully landscaped Japanese gardens that surrounded the Bernheimer residence. For a small fee, visitors could explore the gardens and enjoy the sweeping panorama of Hollywood. In the years following the sale of the property in 1923, the residence fell into disrepair and was almost lost. Fortunately, its historic value was recognized, and the carefully restored building is now open as a restaurant.

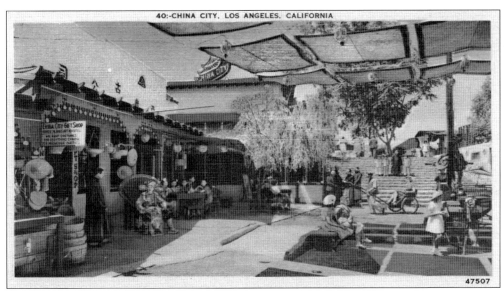

47507

When Los Angeles's original Chinatown was demolished in the 1930s to make way for construction of Union Station, Olvera Street creator Christine Sterling began planning a new tourist attraction where displaced merchants could set up shop. The result was China City, opened in 1938. Vastly different from New Chinatown, which opened in the same year and had been designed and constructed entirely by Chinese Americans, China City offered a theme park atmosphere, where visitors could take rickshaw rides and view staged performances. Damaged by fire, China City closed in 1949.

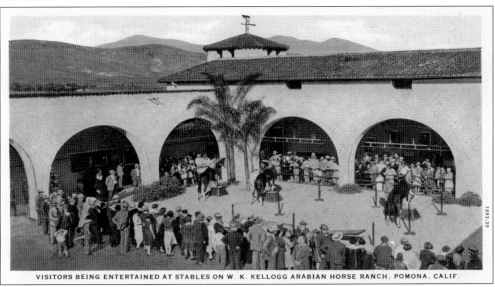

VISITORS BEING ENTERTAINED AT STABLES ON W. K. KELLOGG ARABIAN HORSE RANCH, POMONA, CALIF.

A popular Pomona tourist attraction in the 1920s, the Arabian Horse Ranch was founded in 1925 by cereal manufacturer William K. Kellogg. The ranch operated an Arabian horse-breeding program, and also held exhibitions, frequently attended by Hollywood celebrities. The 750–acre ranch, donated by Kellogg to the University of California in 1932, eventually became part of the Voorhis Campus, a branch of the California State Polytechnic University of San Luis Obispo. Arabian horses are still bred on the campus, which, after separating to form its own college in 1966, finally became the California State Polytechnic University of Pomona in 1972.

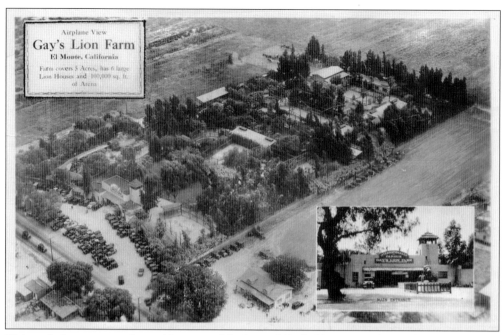

This real photo postcard provides an aerial view of Gay's Lion Farm, located in El Monte at what is now the corner of Peck Road and Valley Boulevard. The attraction was opened in 1925 by Charles and Muriel Gay, who hoped that the lions they bred and trained would be used in the film industry. At its peak, the lion farm was home to over 200 lions, many of whom gained celebrity status for their movie appearances. One of the most well known was Jackie, the roaring lion appearing in the famous MGM logo. As El Monte High School had appropriately selected the lion as their team mascot, the lions also made occasional appearances at football games.

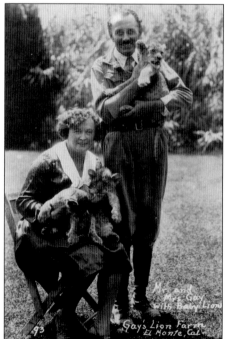

This postcard pictures Charles and Muriel Gay with some of their baby lions. Operated as an amusement park, the farm had lion houses and a variety of performance spaces where visitors could watch lion training exhibits. The lions were relocated to other zoos in 1942 when the lion farm was forced to close its doors due to World War II meat shortages.

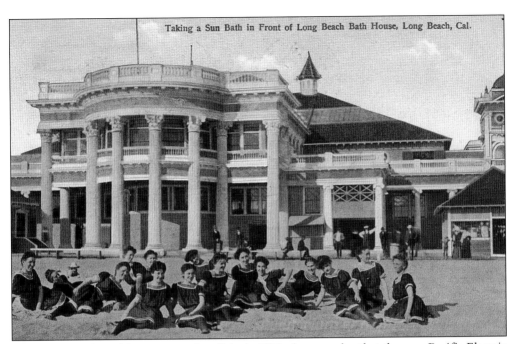

Taking a Sun Bath in Front of Long Beach Bath House, Long Beach, Cal.

The Long Beach Bathhouse opened on July 4, 1902, the same day that the new Pacific Electric line began providing service from downtown Los Angeles. Soon attracting scores of beachgoers, the bathhouse offered a large heated indoor plunge for those not wishing to swim in the cool ocean waves.

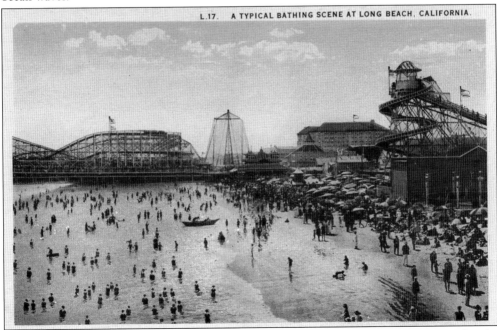

L.17. A TYPICAL BATHING SCENE AT LONG BEACH, CALIFORNIA.

This postcard depicts the crowded beach and amusement zone in Long Beach. Shortly after the bathhouse opened in 1902, a variety of rides, roller coasters, concessions, and venues for dining and dancing began opening on the beachfront near the pier. Known as the Coney Island of the West, the Long Beach Pike attracted hundreds of thousands of yearly visitors.

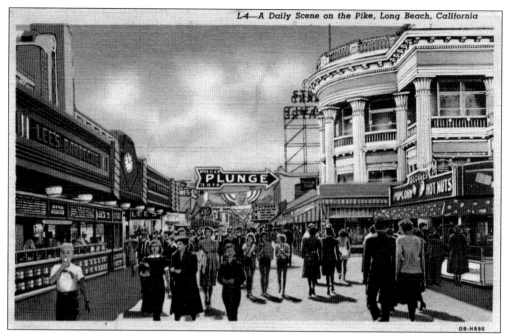

This 1930s postcard provides another view of the famous Long Beach Pike. The bathhouse, once the sole amusement on the beach, is seen at right, surrounded by hundreds of concessions and rides. After decades as a favorite attraction, the Long Beach Bathhouse closed in 1966. The Pike followed shortly thereafter, closing in 1979.

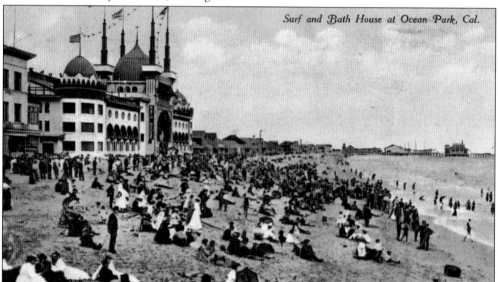

Surf and Bath House at Ocean Park, Cal.

The Ocean Park resort and amusement zone began as a small development by partners Abbot Kinney and Francis Ryan in the 1890s. After Ryan's death in 1898, his share passed to Alexander Fraser, Henry Gage, and George Merrit Jones. As Kinney did not get along with his new partners, the land was divided, with Kinney taking possession of the undeveloped southern half of the tract. The three Ocean Park partners spent the next years adding attractions to the beachfront and pier. Built in 1905, the enormous bathhouse pictured here featured an indoor heated saltwater plunge.

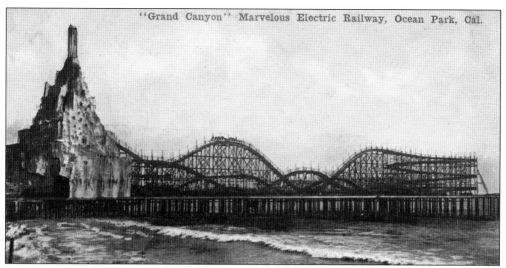

In 1911, Alexander Fraser built Fraser's Million Dollar Pier in Ocean Park, designed to compete with Abbot Kinney's successful Venice of America amusement zone located just to the south. The Grand Canyon Electric Railway roller coaster was one of the prime attractions of the new pier, along with a huge dance pavilion, the Starland Vaudeville Theater, and other concessions. A devastating fire in 1912 destroyed the entire pier and several beachfront blocks of Ocean Park, including the bathhouse.

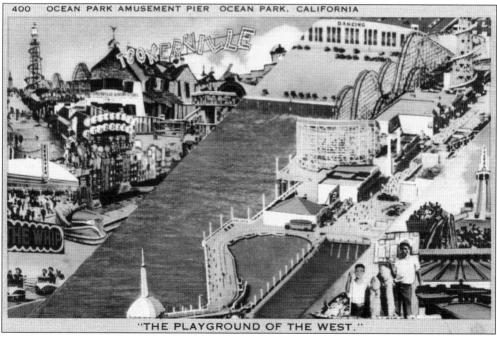

In 1924, another Ocean Park fire consumed the pier Fraser had built in 1913. This postcard depicts several views of the attractions on the new Ocean Park Pier, built in 1925 to replace the burned pier. In 1958, the restyled pier opened as part of Pacific Ocean Park, a nautical-themed amusement park designed to compete with Disneyland. Though hugely popular for many years, Pacific Ocean Park closed in 1967, and the remnants of the vandalized pier were demolished in 1975.

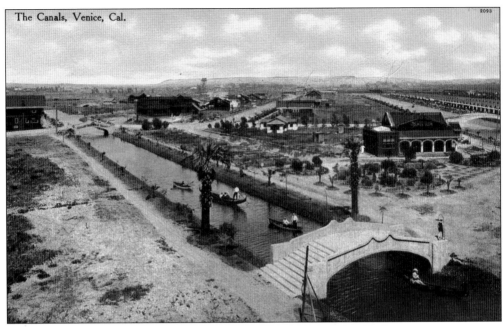

The Canals, Venice, Cal.

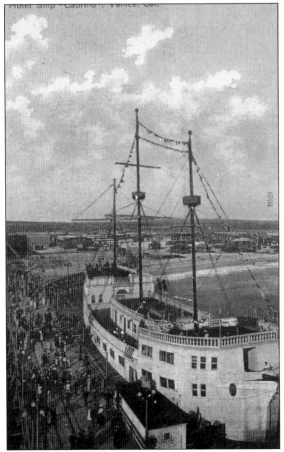

Hotel Ship "Cabrillo", Venice, Cal.

After Abbot Kinney dissolved his partnership with the other three Ocean Park developers in 1904, he gained sole ownership of the undeveloped southern portion of the original tract. Modeled after Venice of Italy, Kinney's new resort town, Venice of America opened with great fanfare on July 4, 1905. One of the main attractions was the system of canals, where visitors could enjoy gondola rides steered by authentic Italian gondoliers.

Shown here is the Ship Café at Venice of America, which opened in 1905 as one of the original attractions of the Venice Pier. To maintain the interest of tourists, new rides and attractions were regularly added to the pier and surrounding beachfront area. The ship and pier were destroyed by fire in 1920, just one year after Kinney's death. A new pier, with a larger Ship Café, dance hall, and rides, was quickly rebuilt by Kinney's son.

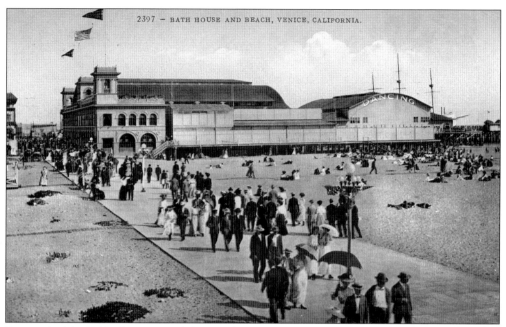

Postmarked in 1912, this postcard depicts the beachfront bathhouse, opened by Kinney at his Venice of America resort in 1908. After the city of Venice voted to be annexed to Los Angeles in 1925, the Venice amusement zone began to slowly disappear. The miniature railway that had transported guests between attractions was removed, and most of the canals were filled in to provide streets in 1929. The Venice Pier was demolished after the city refused to renew the lease in 1946, and many of the Italian-style beachfront buildings were lost in the 1960s and 1970s. Modern preservation efforts have been successful at restoring what remains, and Venice continues to thrive as a popular attraction.

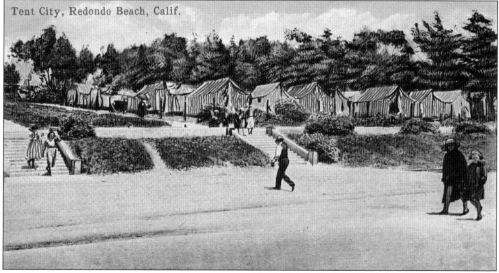

Tent City, Redondo Beach, Calif.

For those who could not afford to stay at one of the resort hotels found in Los Angeles County's beach cities, tent cities, such as the one shown here at Redondo Beach, were the best choice. Usually providing wood floors and some services, as well as a convenient location near the beach, tent cities were a common site near beach amusement areas in the early 1900s.

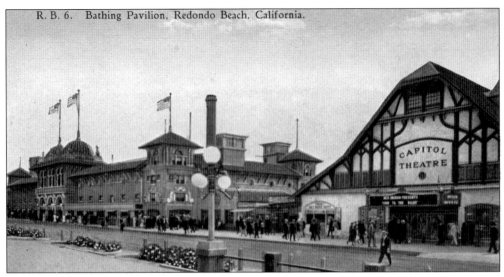

This postcard shows some of the attractions located along the beachfront amusement zone in Redondo Beach. The bathhouse, at left, opened in 1909 among advertisements proclaiming it to be the largest in the world. Featuring a massive indoor saltwater plunge, the bathhouse could accommodate over a thousand bathers at once. The Capitol Theatre, at right, opened in 1912, entertaining beachgoers with both movies and vaudeville shows.

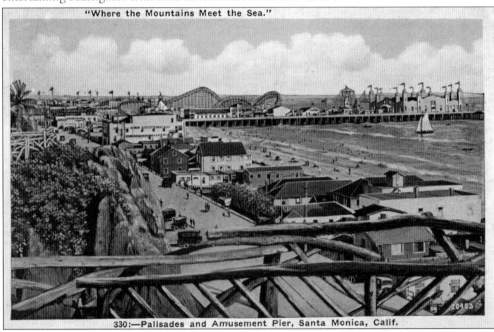

"Where the Mountains Meet the Sea."

330:—Palisades and Amusement Pier, Santa Monica, Calif.

This postcard depicts the Santa Monica Pier as it appeared in the late 1920s. The popular amusement zone featured a roller coaster, rides, and the huge La Monica Ballroom. Opened in 1924, thousands of couples flocked to the ballroom in its heyday to dance to the era's popular swing bands. The roller coaster and rides were removed in the 1930s, and the ballroom was razed in 1963, but the pier managed to escape the fate of most of Los Angeles County's other amusement piers. After successful preservation efforts, the pier reopened as Pacific Park in 1996, offering a full range of amusements, including a roller coaster, for the first time since the 1930s.

Four

RESORTS AND HOTELS

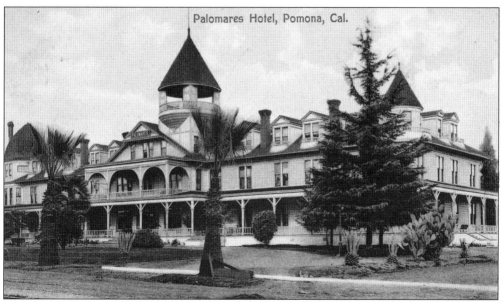

Palomares Hotel, Pomona, Cal.

The Palomares Hotel, constructed in Pomona in 1883, was one of the many tourist hotels and resorts to dot the countryside of Los Angeles County in the 1880s. Such hotels were popular with the Eastern tourists and health seekers who flocked to Southern California at the time pursuing the benefits of the warm sunny climate and mild winters. Pomona, founded in 1875, was an ideal location for a resort, as it was at the time a small citrus growing community boasting a scenic foothill location. The hotel was destroyed by fire in 1911.

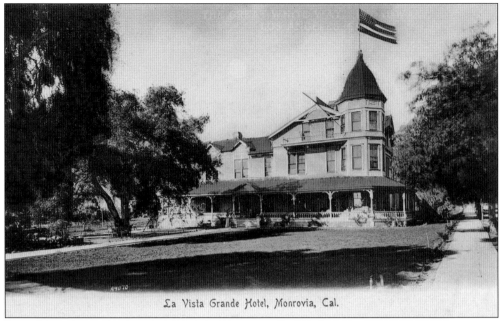

La Vista Grande Hotel, Monrovia, Cal.

During the real estate boom years of the mid–1880s, the developers of many newly formed towns would construct a grand hotel, hoping to provide a sense of sophistication that would attract lot buyers. The Grand View Hotel, regarded as being one of the best appointed in the foothill area, was constructed around the time that Monrovia's first lots went for sale in 1886.

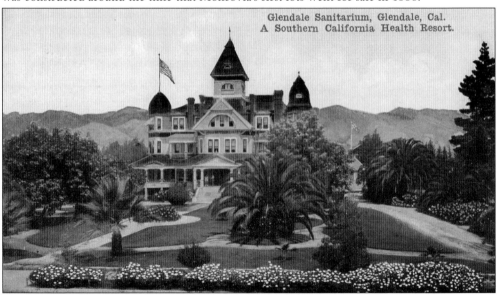

Glendale Sanitarium, Glendale, Cal.
A Southern California Health Resort.

Constructed in 1886 as real estate was booming, this 75-room Victorian mansion began its life as the Glendale Hotel. Located on what is now Broadway Avenue in the newly formed community of Glendale, the hotel was never occupied. In 1905, the building was acquired by Michigan's Battle Creek Sanitarium and converted into the Glendale Sanitarium. More than just a hospital, the sanitarium was advertised as a "health resort," where guests could learn to be healthy in a home like environment. In 1924, the Glendale Sanitarium, the precursor of the Glendale Adventist Medical Center, moved to new larger facilities, and the old hotel was demolished.

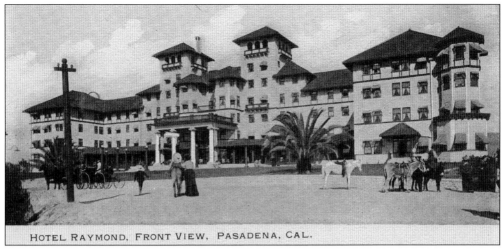

HOTEL RAYMOND, FRONT VIEW, PASADENA, CAL.

Opened in 1886 in Pasadena, the Raymond Hotel was built by Walter Raymond of the Boston tour agency Raymond and Whitcomb. Raymond designed the exclusive resort to provide an appropriate place for the agency's wealthy Eastern clientele to stay during their Los Angeles tours. The original hotel was destroyed by fire in 1895, and the new larger hotel, pictured here, opened in 1901.

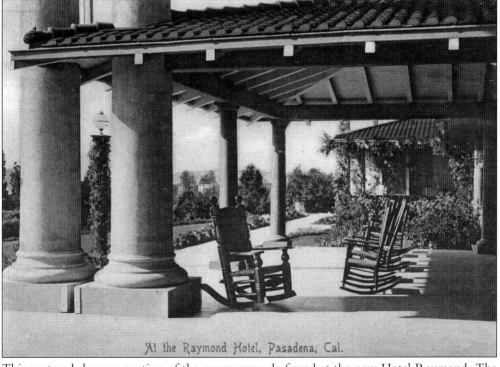

At the Raymond Hotel, Pasadena, Cal.

This postcard shows a portion of the sunny veranda found at the new Hotel Raymond. The hotel was originally designed to house guests arriving as part of a tour group, but it soon became common for wealthy Eastern families to spend the entire winter at the hotel. Though the Raymond Hotel featured numerous activities and amenities to entertain and pamper its long term guests, the combination of the Depression and competition from other Pasadena resorts proved too much for the hotel to withstand. The Raymond Hotel closed, and was demolished in 1934.

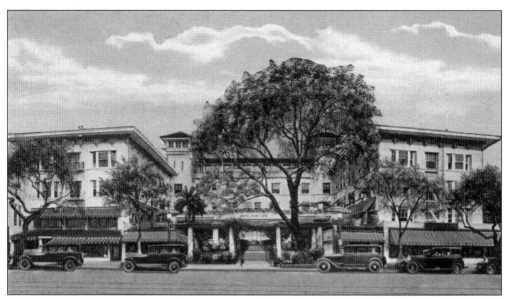

One of Pasadena's popular resort hotels, the Hotel Maryland opened in 1905 at the corner of Colorado Boulevard and Los Robles Avenue. Located in a quiet residential neighborhood, the hotel gained popularity as a tranquil retreat, where one could stay in a park-like setting while still being in proximity to the conveniences and entertainment of Pasadena's downtown area.

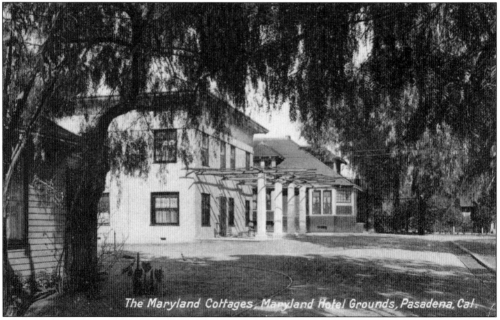

This 1908 postcard depicts some of the cottages at the Hotel Maryland. Often credited with inventing the idea of including cottages as part of a resort hotel, the Hotel Maryland began constructing private bungalows as an alternative to the main hotel. Each cottage was unique, built to the specifications of an individual Eastern family, who would return to the cottage each winter. Similar to private residences, except for the lack of a kitchen, the cottages combined the familiarity of home with the services and amenities of a hotel. Despite its popularity, the hotel suffered during the Depression and was closed shortly thereafter.

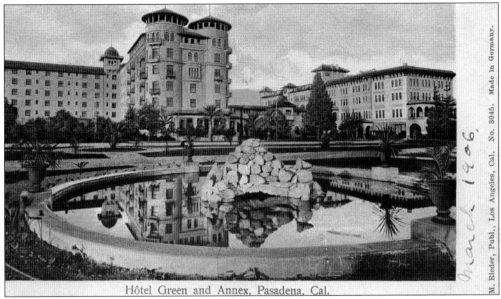

Hôtel Green and Annex, Pasadena, Cal.

This 1906 postcard shows the Hotel Green, one of Pasadena's famed resort hotels. Colonel G.G. Green, one of the many wealthy Easterners who spent the winter in Pasadena, opened the hotel in 1890 in the building formerly used as the Webster Hotel. The hotel was so prosperous that two annexes, seen at left, were constructed in 1894 and 1899, and connected to the main hotel by an enclosed bridge crossing Raymond Avenue. In the 1920s, the hotel was divided into three separate properties: the Hotel Pasadena in the original wing, the Hotel Green in the wing at far left of the image, and the Castle Green Apartments, opened by a group of regular Hotel Green guests, in the other wing. Most of the bridge crossing Raymond Avenue was removed after the Hotel Pasadena was closed and demolished in 1935.

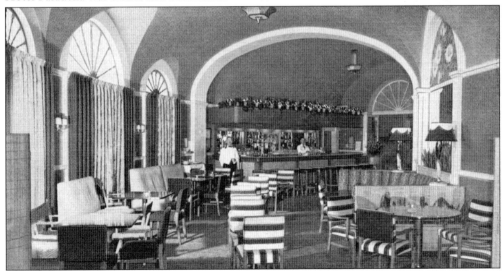

Shown here is the Green Terrace, a popular cocktail and supper lounge at the Hotel Green in the 1950s. After the original hotel had been divided in three, the Hotel Green operated in the wing facing Green Street until 1964. The former hotel was remodeled and reopened in the 1970s as senior apartments. The wing facing Raymond Avenue continues to retain much of its original charm as the Castle Green Apartments.

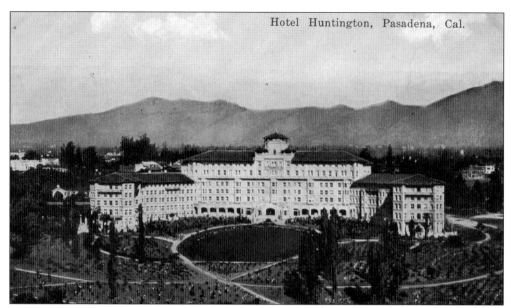

Hotel Huntington, Pasadena, Cal.

Located on a hill of Henry Huntington's Oak Knoll property in Pasadena, the Hotel Wentworth opened in 1907. After early financial problems, Huntington obtained ownership of the hotel, changing its name to the Hotel Huntington and adding two floors for its reopening in 1914. The exclusive hotel boasted of easy railway access and panoramic vistas of everything from the surrounding orange groves to the Pacific Ocean. Now known at the Langham Huntington, it is the only hotel from Pasadena's famed resort era to remain in operation.

Postmarked in 1937, this postcard depicts the Hotel Vista del Arroyo in its final years as one of Pasadena's renowned resorts. Beginning as a small guest house in 1882, the hotel expanded over the years into the grand 400-room hotel pictured here. Popular for its sweeping vistas of the arroyo, the structure's days as a hotel ended in 1943 when it was procured under the War Powers Act to serve as a hospital. Used for years as offices for the U.S. Army, the landmark hotel was remodeled in 1980 to house the Ninth Federal Circuit Court of Appeals.

74

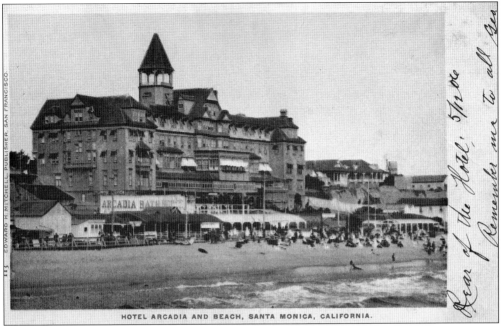

HOTEL ARCADIA AND BEACH, SANTA MONICA, CALIFORNIA.

When the Arcadia Hotel opened in 1887, it was the largest building in Santa Monica. Named for the wife of Santa Monica cofounder Robert Baker, the beachfront hotel was one of the finest resorts on the coast and even had its own bathhouse, visible near the bottom left of this 1906 postcard. Despite the popularity of the amusements surrounding the nearby pier, the hotel experienced low occupancy and was razed in 1909.

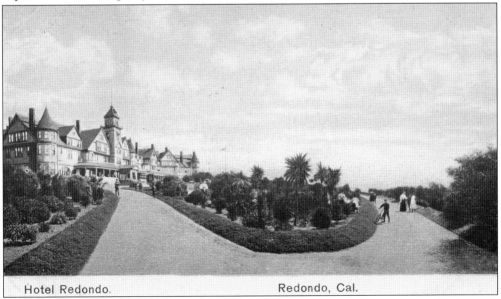

Hotel Redondo. Redondo, Cal.

The Hotel Redondo debuted in 1890, offering a resort setting for tourists visiting popular oceanfront town Redondo Beach. The hotel overlooked the beach from its vast landscaped grounds, and even had an 18 hole golf course. Despite new beach attractions opening in the early 1900s, including a large pavilion and bathhouse, the hotel declined and was demolished in 1926.

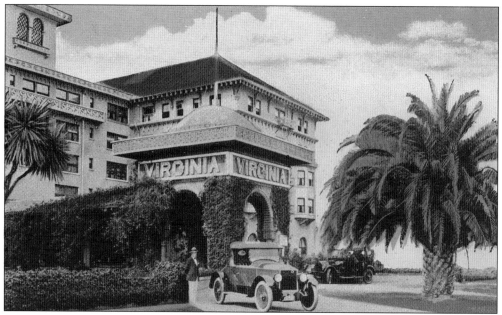

This postcard depicts the entrance of the Hotel Virginia, early Long Beach's most famous hotel. The resort hotel catered to wealthy Easterners, and was regarded as the finest beach hotel on the Pacific. The hotel was constructed by a group of investors organized by Charles Drake, who had played a significant role in bringing a Pacific Electric line to Long Beach in 1902. Drake also built the Long Beach Bathhouse, which became a central part of the expansive amusement district known as the Pike.

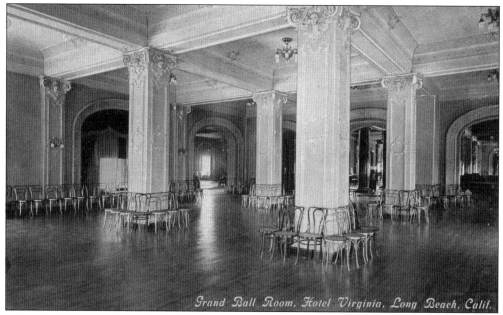

Shown here is the grand ballroom of the Hotel Virginia. Convenient to the Pike amusement zone and the Long Beach pier, the beachfront hotel offered many elegant amenities. Although the surrounding beach attractions remained popular during the Depression, the hotel was demolished in the early 1930s.

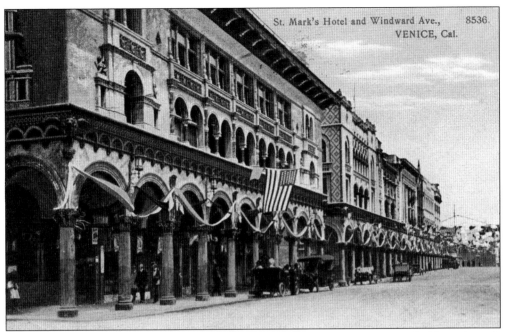

This 1908 postcard pictures St. Mark's Hotel, which opened in 1905 as part of Abbot Kinney's Italian-themed Venice of America resort. The town featured gondola-filled canals, a bathhouse, auditorium, dance hall, and amusement pier. Located on colonnaded Windward Avenue, the hotel was renowned during the resort's peak years, and even provided guests with hot saltwater piped to their rooms. The pier closed in 1946, and the hotel, along with many of the other Italian-themed buildings on Windward Avenue, was razed in the 1960s.

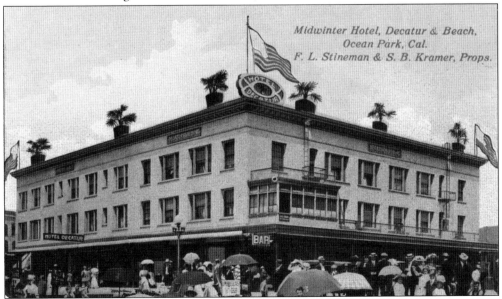

Midwinter Hotel, Decatur & Beach,
Ocean Park, Cal.
F. L. Stineman & S. B. Kramer, Props.

The Hotel Decatur, opened in 1906, was one of the finest to be constructed in the resort town of Ocean Park. Guests at the hotel were in prime position to enjoy the town's attractions, including a dance hall, beach boardwalks, amusement pier, and an enormous beachfront bathhouse. The hotel was consumed by the fire that destroyed much of the Ocean Park beachfront and pier in 1912.

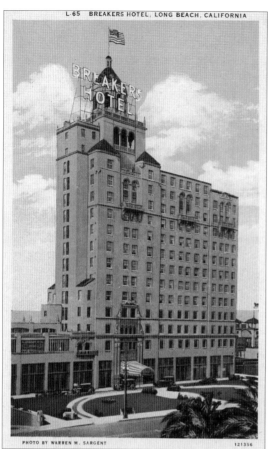

L-65 BREAKERS HOTEL, LONG BEACH, CALIFORNIA

PHOTO BY WARREN M. SARGENT 121356

Opened in 1926 in downtown Long Beach, the Breakers Hotel was one of Southern California's premier beach hotels for many years. After a decline during the Depression, the hotel became part of the Hilton chain when Conrad Hilton purchased it in 1938. Hilton converted the penthouse to the Sky Room, which until 1947 was one of the area's most popular restaurants, frequented by celebrities of the day. After many changes of ownership, the hotel is now a retirement home. However, visitors may still dine at the restored Sky Room, which reopened in 1997.

One of a string of resorts constructed to take advantage of the pleasant scenery and ideal weather offered by the foothill communities, the Flintridge Hotel ended up being a short-lived endeavor. Designed by Myron Hunt, the mission-style hotel opened in 1927, only to be closed a few years later when the Depression hit. Since 1931, the hotel has been operated as Flintridge Sacred Heart Academy.

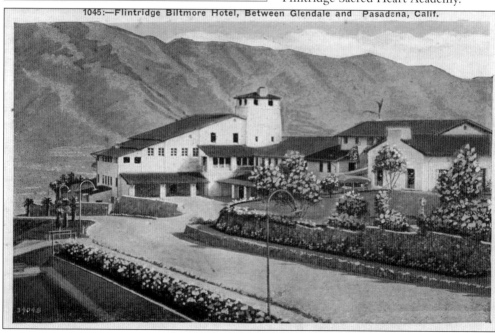

1045:—Flintridge Biltmore Hotel, Between Glendale and Pasadena, Calif.

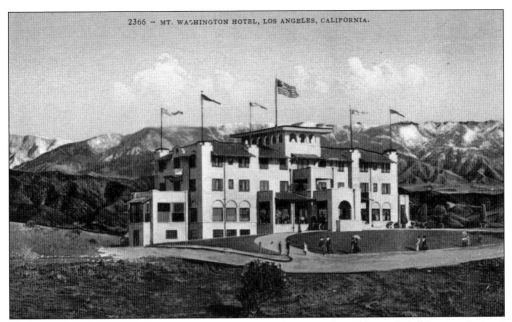

The Mount Washington Hotel opened in 1910 on the summit of Mount Washington, located northeast of downtown Los Angeles. The 18-room hotel was constructed by developer Robert Marsh as a means of attracting visitors to his new subdivision. The hotel offered a commanding view of the entire Los Angeles area, from the mountains to the sea.

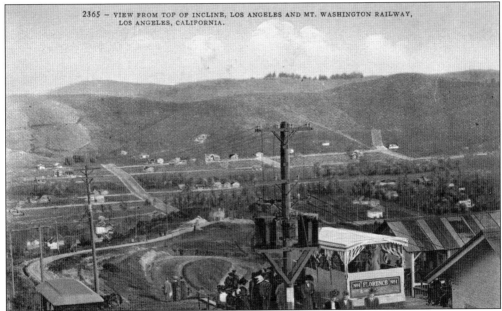

This postcard depicts the Los Angeles and Mount Washington Railway, an incline railway constructed in 1909 by Robert Marsh to provide access to the hotel and real estate development located on Mount Washington's summit. For several years, the hotel was a popular lunch destination for visitors seeking a panoramic view of the city. However, the incline discontinued service in 1919, and the hotel closed in 1921. The hotel was purchased in 1925 by the Self Realization Fellowship, which continues to use the building as their international headquarters.

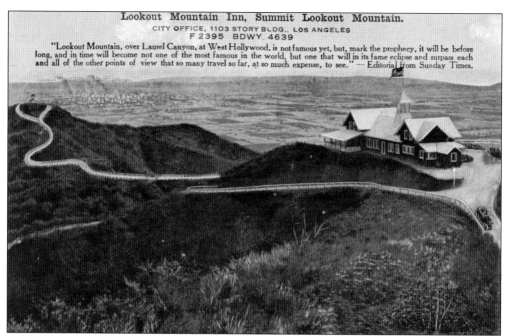

Lookout Mountain Inn, Summit Lookout Mountain.
CITY OFFICE, 1103 STORY BLDG., LOS ANGELES
F 2395 BDWY. 4639
"Lookout Mountain, over Laurel Canyon, at West Hollywood, is not famous yet, but, mark the prophecy, it will be before long, and in time will become not one of the most famous in the world, but one that will in its fame eclipse and surpass each and all of the other points of view that so many travel so far, at so much expense, to see." — Editorial from Sunday Times.

Constructed in the early 1910s by developer Charles Mann, Lookout Mountain Inn offered sweeping views of everything from nearby Hollywood to the Pacific Ocean. Perched on the summit of Lookout Mountain, the 24-room inn was designed to help promote the new Laurel Canyon development Mann called Bungalow Land. The inn was destroyed by fire in 1920.

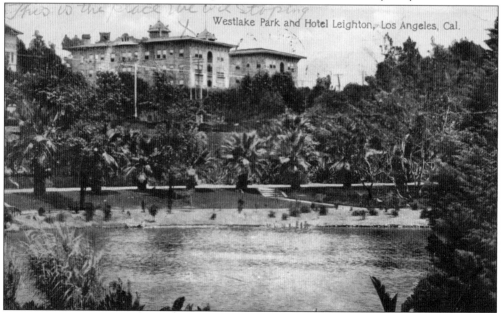

This 1913 postcard was sent by a guest of the Hotel Leighton, which was built in 1904 overlooking Westlake Park, now known as MacArthur Park. One of Los Angeles's largest parks, Westlake Park was a popular weekend destination for strolling, boating, and concerts. The park and hotel were surrounded by the exclusive residential neighborhood along Wilshire Boulevard developed by Henry Gaylord Wilshire in the 1890s.

Calling itself "the best appointed hotel in Southern California," the Hollenbeck Hotel opened in 1884 at the corner of Spring and Second Streets. Named for its owner John Hollenbeck, a prominent investor, banker, and landholder, the hotel was one of downtown's most popular. However, the aging hotel was unable to compete with newer hotels, and was razed in 1933.

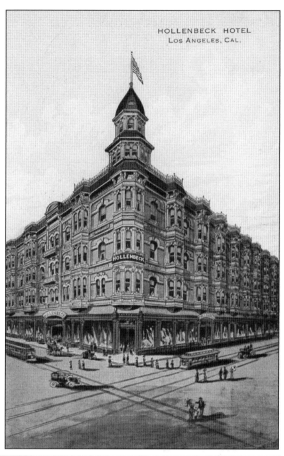

Postmarked in 1908, this postcard shows the Angelus Hotel, for many years one of the most fashionable in downtown Los Angeles. Located at Spring and Fourth Streets, the hotel opened in 1901 with the distinction of being the tallest structure in the city. Later eclipsed in popularity by newer luxury hotels such as the Alexandria Hotel, the Angelus was demolished in 1956.

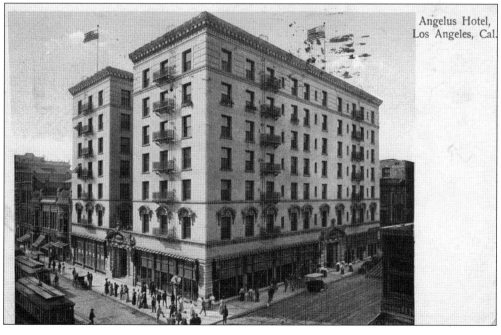

81

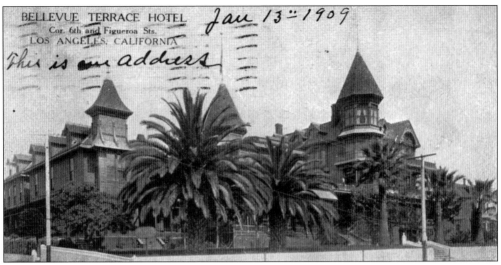

This 1909 postcard shows the Bellevue Terrace Hotel, a Victorian-style hotel and boardinghouse. At the time it was built in the 1880s at Figueroa and Sixth Streets, the hotel was surrounded by a quiet residential neighborhood. However, as the city's downtown business center began rapidly expanding in the early 1900s, residences began giving way to stores and office buildings. The Jonathan Club, one of Los Angeles's prominent business and social clubs, constructed their new headquarters on the site of the demolished hotel in 1924.

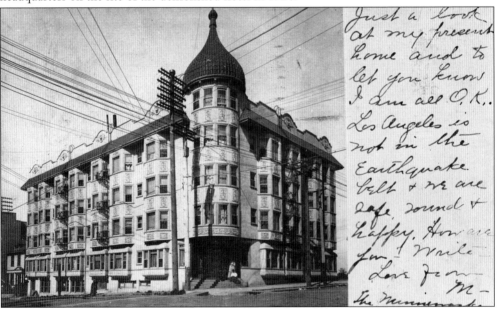

The Minnewaska Hotel was one of the many hotels and rooming houses to operate in the Bunker Hill neighborhood of downtown Los Angeles. The author of this 1906 postcard stayed at the Minnewaska, later renamed the Dome Hotel, not long after it was constructed at Grand Avenue and Second Street. Bunker Hill, a fashionable neighborhood of Victorian mansions when it was first developed in the 1870s, began to decline in the early 1900s as families moved to newer districts further from the city center. The Minnewaska Hotel burned in 1964, around the time the entire Bunker Hill neighborhood was being demolished as part of a giant urban renewal project. The site of the former neighborhood is now the realm of the city's skyscrapers.

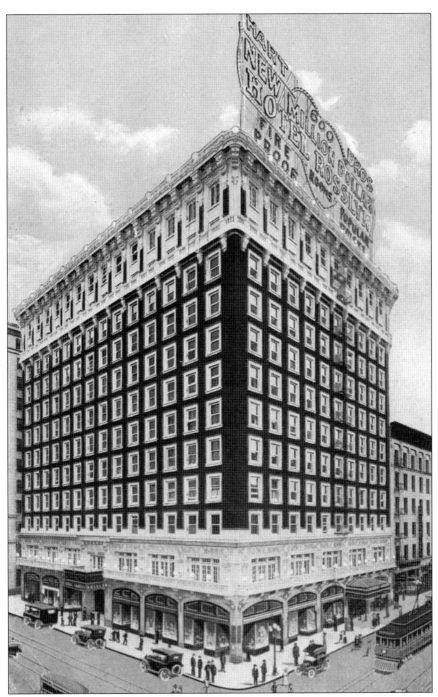

In 1905, Los Angeles hoteliers George and Dwight Hart purchased the Hotel Rosslyn, turning the small hotel within a few years into one of the city's largest. As the hotel's popularity grew, the brothers constructed two new buildings at Main and Fifth Streets. The main building, built in 1913 and famously known as the Million Dollar Hotel, appears here. A matching annex was added 10 years later across the street. As with many of the historic downtown hotels, the Hotel Rosslyn has been converted for residential use.

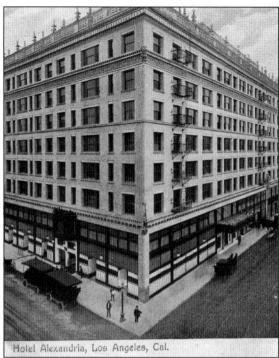

Hotel Alexandria, Los Angeles, Cal.

The Alexandria Hotel opened in 1906 at the corner of Spring and Fifth Streets, rapidly building a reputation as a center of social life. The luxury hotel was for many years the place to see and be seen, attracting foreign dignitaries, U.S. presidents, and movie celebrities. Designed by John Parkinson and G. Edwin Bergstrom, the hotel's best-known feature was its grand marble and gold-leaf lobby.

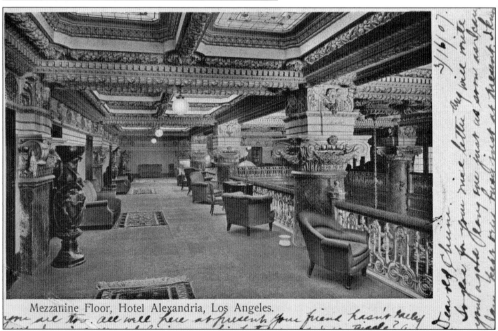

Mezzanine Floor, Hotel Alexandria, Los Angeles.

This 1907 postcard provides a view of the Alexandria Hotel's mezzanine level. After popularity waned due to competition from newer hotels such as the Biltmore Hotel, the Alexandria experienced a string of owners who continually remodeled it in attempt to regain the hotel's former glory. The gold leaf and chandeliers were stripped and sold in the 1930s, and the mezzanine level was later closed in to create a second level, resulting in a lower lobby ceiling. After years of decline, the rooms of the Alexandria Hotel have been renovated into affordable loft residences.

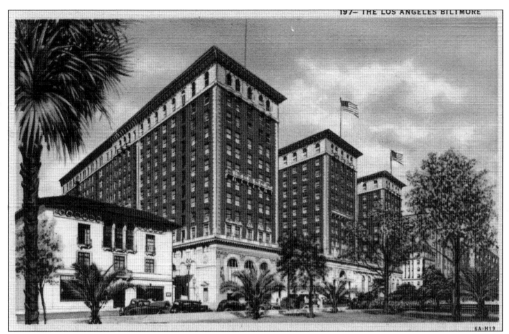

The Biltmore Hotel, which overlooks Pershing Square from Olive Street between Fifth and Sixth Streets, opened in 1923 as the largest and finest hotel west of Chicago. The grand hotel, designed by New York architects Leonard Schultze and S. Fullerton Weaver, features elaborate wall and ceiling murals painted by Italian artist Giovanni Smeraldi. Unlike many of downtown's historic hotels which are now used as residences, the Biltmore continues to welcome guests as a luxury hotel.

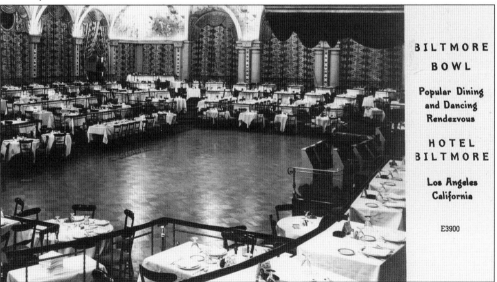

BILTMORE BOWL

Popular Dining and Dancing Rendezvous

HOTEL BILTMORE

Los Angeles California

E3900

This real photo postcard shows the Biltmore Bowl, a popular nightclub at the Biltmore Hotel in the 1930s and 1940s. Frequented by movie stats of the day, the Bowl featured dining and dancing to live big band entertainment. The Bowl also hosted several early Academy Award ceremonies. Having undergone several remodels and renovations over the years, the Biltmore Bowl is now available only for private events.

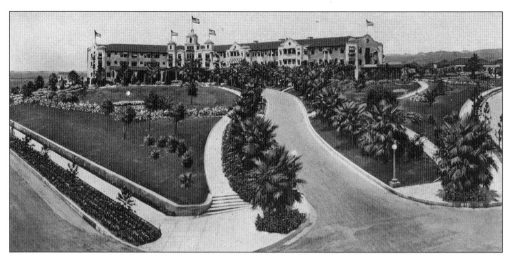

The Beverly Hills Hotel opened in 1912, surrounded by acres of fields in the still-undeveloped area west of downtown Los Angeles. Developer Burton Green hoped the hotel would attract buyers to his newly planned Beverly Hills residential development. Designed to be an exclusive neighborhood, Beverly Hills became a celebrity enclave after 1920, when Hollywood stars Mary Pickford and Douglas Fairbanks constructed their home there. As other stars began building their homes in the new development, the hotel became a popular social spot, serving as both a celebrity retreat and as host for glamorous parties.

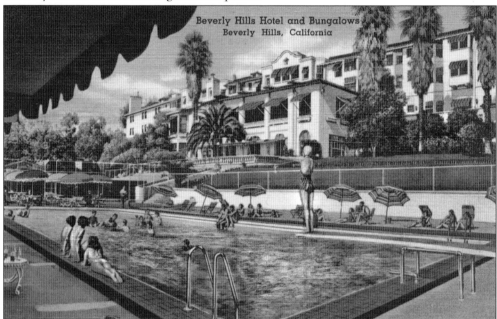

This postcard provides a view of the Beverly Hills Hotel pool, enjoyed over the years by a host of famed guests. In addition to the main hotel, the grounds also contain a variety of bungalows, offering patrons the comforts of a single family home during an extended stay. Enjoying the privacy they offer, countless celebrities, including Howard Hughes, Elizabeth Taylor, Marlene Dietrich, and Marilyn Monroe, were known to frequent the bungalows. After a two-and-a-half-year renovation in the early 1990s, the hotel continues to maintain its popularity from its prime location on Sunset Boulevard.

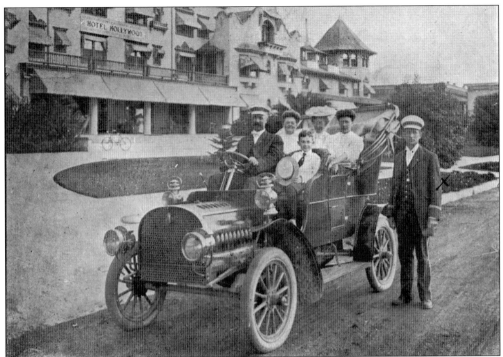

The Hollywood Hotel, famed as a movie industry social center, was actually constructed several years before the first movie studio arrived in Hollywood in 1911. Built in 1902 by developer H. J. Whitley, the hotel was designed to draw buyers to the new residential community he had planned. Operated as a resort, the hotel was expanded several times, eventually covering an entire block on Hollywood Boulevard.

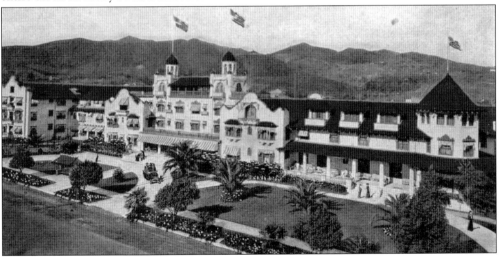

As the movie industry prospered, the Hollywood Hotel became a favorite place for the celebrities of the day to stay and socialize. The hotel became the place to see and be seen, with stars regularly dining there and attending the famous weekly dances held in the hotel's grand ballroom. Despite the central place it held in Hollywood life, the Hollywood Hotel was demolished in the 1950s. The site is now occupied by the Hollywood and Highland entertainment complex, which opened in 2001.

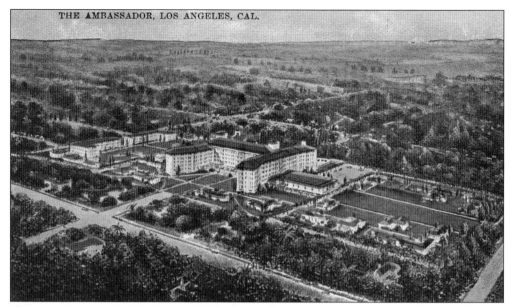

The most famous hotel in Los Angeles, the Ambassador Hotel, opened with much fanfare on January 1, 1921. Popular from the start, the hotel was located on 23 acres along Wilshire Boulevard, at the time a mostly undeveloped area. As celebrities began to frequent the hotel, the surrounding neighborhood became prime real estate, and Wilshire became one of the city's most important boulevards.

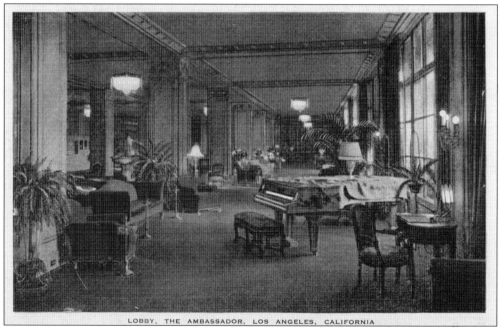

Shown here is the lobby of the renowned Ambassador Hotel. Designed by architect Myron Hunt, the hotel quickly accrued an impressive list of past visitors, including countless celebrities, foreign dignitaries, and several U.S. presidents. For the convenience of its guests, hotel grounds included private cottages, several retail stores, a post office, bank, and a pool complete with an artificial beach.

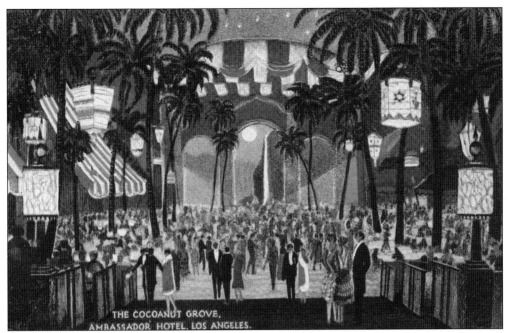

Opened in 1921, the Cocoanut Grove at the Ambassador Hotel was one of Los Angeles's hottest nightclubs. In its heyday, countless celebrities danced the night away at the Grove, enjoying performers such as Frank Sinatra, Bing Crosby, Louis Armstrong, and Judy Garland. The popular hotel also hosted six Academy Awards ceremonies in the 1930s and 1940s.

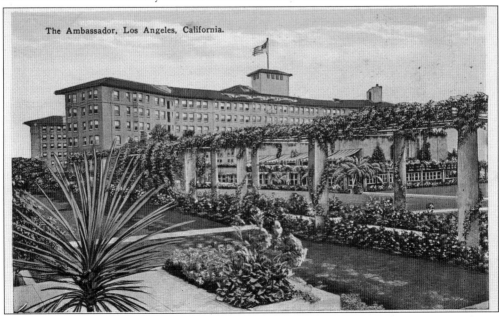

On June 5, 1968, the Ambassador Hotel entered its darkest days when presidential candidate Sen. Robert F. Kennedy was gunned down in the pantry area following a speech. In the ensuing years, the hotel and the surrounding neighborhood declined, finally leading to the hotel's closing in 1989. Despite efforts to save it, the hotel was demolished in 2005. The Los Angeles Unified School District opened the Central Los Angeles Learning Center on the site in 2009.

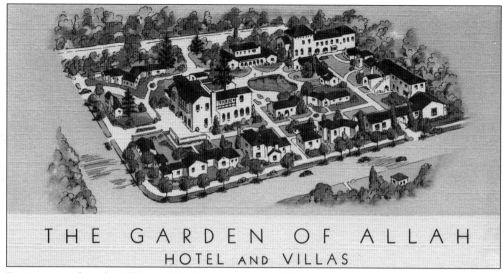

THE GARDEN OF ALLAH
HOTEL AND VILLAS

During its peak in the 1930s and 1940s, the Garden of Allah was one of Hollywood's best-known spots, where celebrities came to visit, live, or attend the notorious parties held there. The hotel originated in 1927, when silent film star Alla Nazimova converted her private residence on Sunset Boulevard into a hotel, also adding an additional 25 guest bungalows onto the extensive grounds. Soon a center of social life, the hotel was frequented by John Barrymore, Ernest Hemingway, Marlene Dietrich, Clara Bow, Greta Garbo, Humphrey Bogart, the Marx Brothers, and countless others. The hotel had begun to decline by the late 1940s and was razed in 1959.

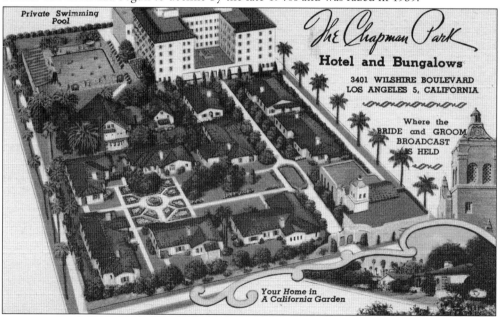

One of several hotels and apartment houses to be constructed in the fashionable Wilshire district in the 1920s, the Chapman Hotel opened just off of Wilshire Boulevard in 1925. The hotel gained fame when it was used to house the female athletes during the 1932 Los Angeles Olympics. In order to increase its presence on Wilshire Boulevard, which had become a major thoroughfare, bungalows were added in 1936 and the hotel was renamed the Chapman Park Hotel and Bungalows. The hotel was demolished in the 1960s and replaced by an office building.

Five

LANDMARKS

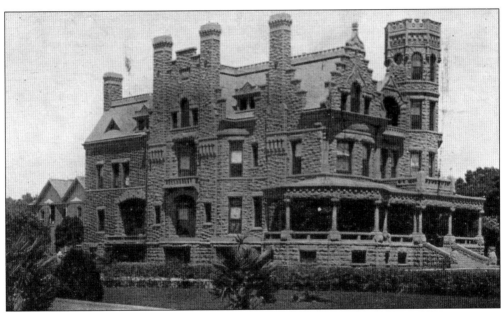

Designed to encourage wealthy Easterners to visit, scores of early Los Angeles postcards were printed with the images of prominent homes. This 1907 postcard depicts the Stimson House, built for Chicago lumberman Thomas Douglas Stimson when he retired to Los Angeles in 1890. Located on a stretch of Figueroa once known as Millionaire's Row, the mansion has been used for a variety of purposes. It served as a University of Southern California fraternity house in the 1940s, then as a convent, and eventually as student housing for Mount St. Mary's College students. In 1993, the Sisters of St. Joseph of Carondelet returned to the house, and they have used it as a convent since then.

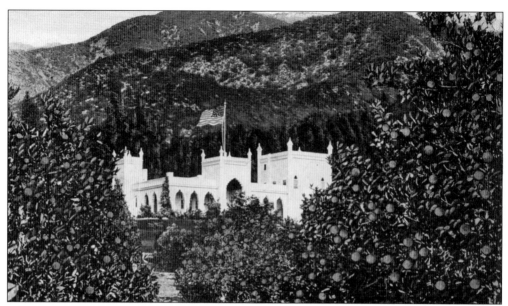

Located in the foothills overlooking Glendale, the home known as El Miradero, or as Brand Castle, was constructed in 1904 for Leslie Brand. A prominent real estate developer and landholder, Brand helped jumpstart the town's growth when he partnered with Henry Huntington to bring a Pacific Electric line to Glendale in 1904. Although it no longer overlooks the orange groves of a small town, the house Brand willed to the city is still enjoyed by patrons of the Brand Library.

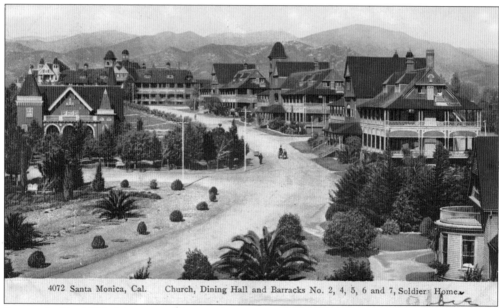

4072 Santa Monica, Cal. Church, Dining Hall and Barracks No. 2, 4, 5, 6 and 7, Soldiers Home.

Postmarked in 1907, this postcard depicts the Old Soldiers Home, founded in 1887 as the Pacific Branch of the National Home for Disabled Volunteer Soldiers. Constructed during the 1880s and 1890s near Santa Monica, the scenic grounds became a tourist destination in the early 1900s when the popular Balloon Route trolley excursion added the home as one of its stops. All of the original structures have been demolished, but the Wilshire Boulevard site continues to serve veterans as the VA West Los Angeles Healthcare Center.

92

Dr. A. G. Schloesser's Mansion, Castle Sans Souci, Hollywood, Cal.

Castle San Souci was one of early Hollywood's most well-known landmarks, built at a time when wealthy Easterners came west to create the home of their dreams. The castle was constructed by Dr. A. O. Schloesser after he arrived in Los Angeles in 1909. Located at Franklin Avenue and Argyle Street through the 1920s, the mansion housed Schloesser's impressive art collection.

MISSION PLAYHOUSE, SAN GABRIEL, CALIFORNIA M23

Constructed in 1927, the Mission Playhouse in San Gabriel was designed specifically to present the "Mission Play" by John Steven McGroarty. Dramatizing the story of the California missions, the popular play was showcased there until 1932. Following a stint as a movie house, the Mission Playhouse has been restored for use as a live entertainment venue.

577 The City Hall, Los Angeles, Calif.

One of the most impressive structures in early downtown Los Angeles, the building pictured here was constructed in 1888 to serve as Los Angeles City Hall. The city grew rapidly as the result of the 1880s real estate boom, and the new structure demonstrated to the booming populace that Los Angeles's pueblo days were a thing of the past. Soon inadequate as the city continued to expand, the building was demolished when the current Los Angeles City Hall opened in 1928.

This postcard shows two of the civic landmarks of early downtown Los Angeles. At left is the red sandstone Los Angeles County Courthouse, constructed in 1891 at the corner of Broadway and Temple Street. At right is the Hall of Records, completed in 1912. As Los Angeles's population increased in the 1920s, a new civic center was planned, and the old courthouse was demolished in 1936. The Hall of Records, appearing askew after streets were realigned during the development of the modern civic center, lingered on until 1973.

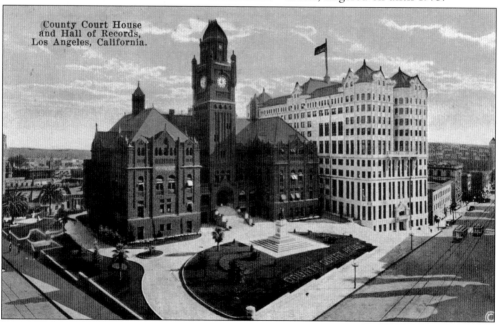

County Court House and Hall of Records, Los Angeles, California.

This 1909 postcard depicts the Auditorium, which at its opening in 1906 was the largest building in the world to have been constructed of reinforced steel and concrete. Home to the Temple Baptist Church, the Auditorium was also used for concerts and musicals, including the winter performances of the Los Angeles Philharmonic Orchestra from 1920 to 1964. The building overlooked Central Park from the corner of Fifth and Olive Streets until it was demolished in 1985. The site is now a parking lot.

This 1940s postcard depicts René and Jean, which opened in the 1920s on Seventh Street. Quickly becoming one of the city's leading French restaurants, René and Jean added a second larger location on Olive Street in 1933.

BULLOCK'S, LOS ANGELES. 95982

In the early 1900s, Broadway began developing as downtown Los Angeles's foremost shopping and entertainment destination, boasting a high concentration of theaters and department stores. This postcard depicts Bullocks Department Store, which grew from its founding in 1907 to become one of the city's largest, eventually occupying the entire block on Seventh Street between Broadway and Hill Street. As a result of the popularity of suburban shopping malls, the last of the major department stores on Broadway had closed by the 1980s. The Bullocks building is now used as St. Vincent's Jewelry Center.

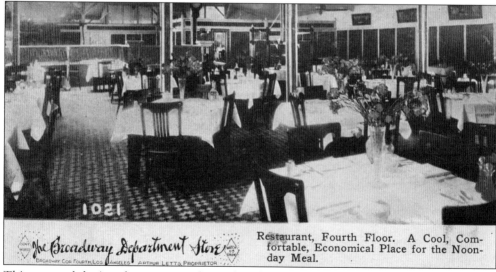

Restaurant, Fourth Floor. A Cool, Comfortable, Economical Place for the Noonday Meal.

This postcard depicts the restaurant located in the Broadway Department Store, which was located at Broadway and Fourth Street. Founded by Arthur Letts in 1896, the store expanded to become one of the city's most popular. As was customary for major department stores, the Broadway offered its guests numerous amenities, including a restaurant, tea room, meeting rooms, and parlors.

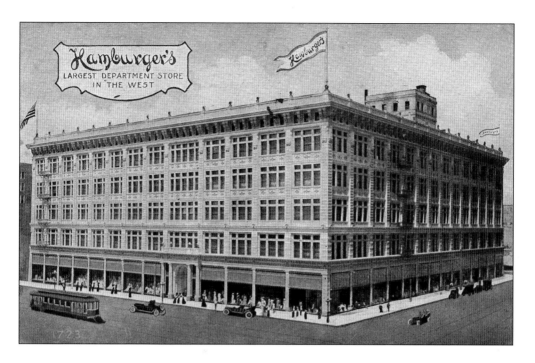

The above postcard features Hamburger's Department Store, known as the "Great White Store." Founded by Asher Hamburger in 1881, the small store grew to become the largest west of Chicago when its new building was opened at Broadway and Eighth Street in 1908. Containing the first escalator in the city, the store reportedly attracted a crowd of 80,000 visitors on its grand opening. The postcard below depicts a few of the massive store's many specialized departments. In 1923, the store was acquired by the May Department Store, which has also since ceased to exist.

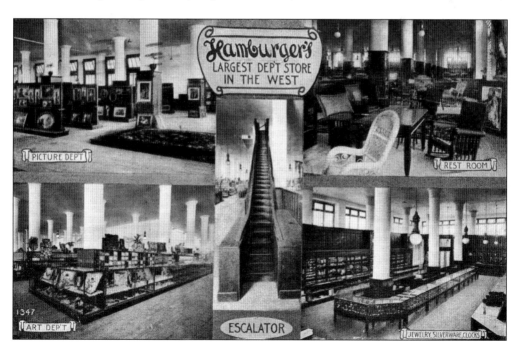

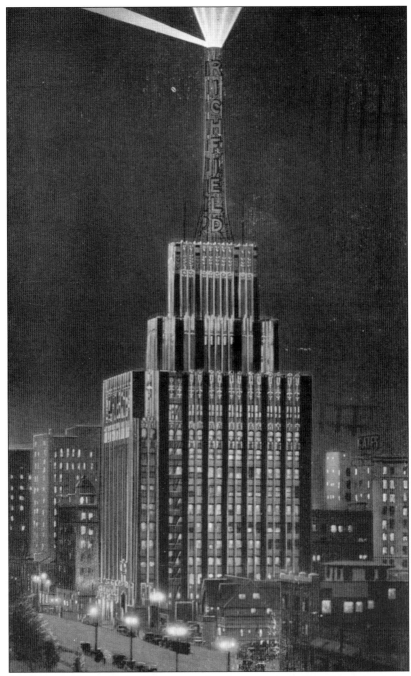

One of the most recognizable buildings on the downtown skyline for several decades, the Richfield Oil Building opened in 1929 at Flower and Sixth Streets. Designed by Morgan, Walls, and Clements, the building's black terra cotta, accented with gold strips, was meant to symbolize the black gold wealth of an oil field. Special permission had to be obtained for the skeleton steel signage tower to be placed atop the building, since the total height exceeded the 150-foot height limit in place from 1906 to 1957. The Richfield building was demolished in 1969 and replaced in 1972 with the twin 52-story towers of Arco Plaza, now known as City National Plaza.

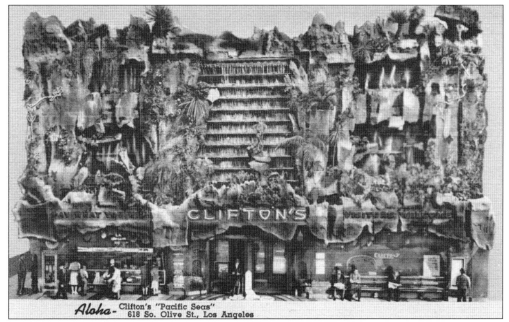

Aloha – Clifton's "Pacific Seas"
618 So. Olive St., Los Angeles

Opened by Clifford Clinton on Olive Street in 1931, Clifton's Pacific Seas Cafeteria, shown above with its distinctive tropical façade, was a must-see tourist stop and a favorite downtown dining spot. Visitors dined among the elaborate tropical décor, which included waterfalls and a rain hut, and enjoyed daily live entertainment. Operating under the slogan "Pay what you wish or dine free unless delighted," Clinton opened a second themed cafeteria on Broadway near Seventh Street in 1935. Decorated to recreate a woodland scene, this second restaurant, seen below, featured terraced dining among redwood groves, waterfalls, caves, and rock sculptures. Although the Pacific Seas Cafeteria closed in 1960, downtown visitors continue to enjoy the forest setting of the Brookdale Cafeteria.

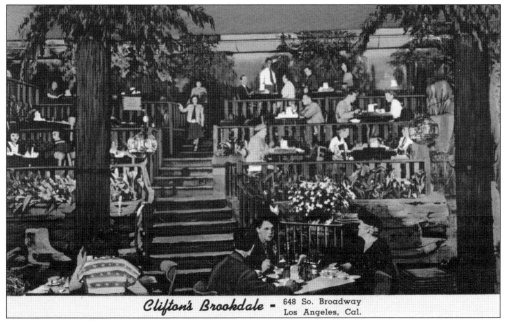

Clifton's Brookdale – 648 So. Broadway
Los Angeles, Cal.

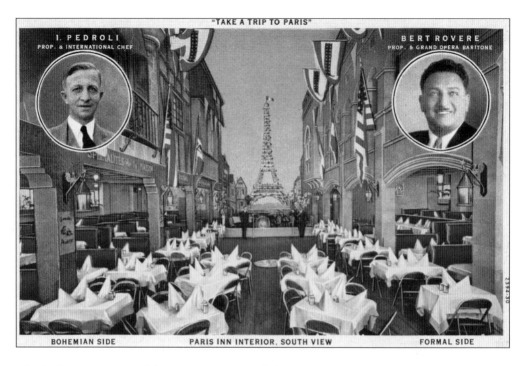

"TAKE A TRIP TO PARIS"

I. PEDROLI
PROP. & INTERNATIONAL CHEF

BERT ROVERE
PROP. & GRAND OPERA BARITONE

BOHEMIAN SIDE PARIS INN INTERIOR, SOUTH VIEW FORMAL SIDE

The Paris Inn was one of downtown Los Angeles's most unique restaurants from the 1920s to the 1950s. Offering French-Italian cuisine, the restaurant was known for its singing waiters and Parisian revues. After their restaurant on Market Street, seen above, was demolished in 1950 to build a new city jail, the Paris Inn moved to their third and final location, pictured below, on Broadway in what is now Chinatown.

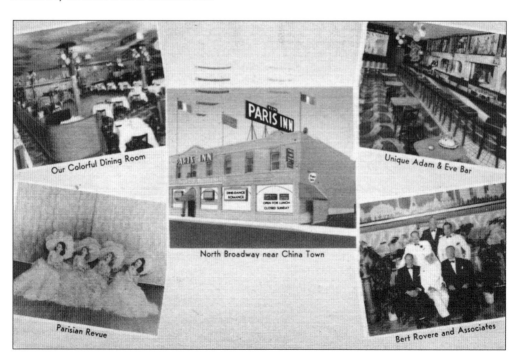

Our Colorful Dining Room

PARIS INN

North Broadway near China Town

Unique Adam & Eve Bar

Parisian Revue

Bert Rovere and Associates

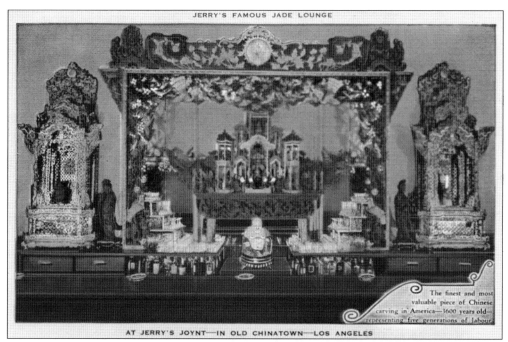

The finest and most valuable piece of Chinese carving in America—3600 years old—representing five generations of labour.

AT JERRY'S JOYNT—IN OLD CHINATOWN—LOS ANGELES

Postmarked in 1943, this postcard depicts the elaborate carving of the bar at Jerry's Joynt, a popular dining and night spot in the 1930s and 1940s. Known for its Jade Lounge, Jerry's Joynt was located on Ferguson Alley in Los Angeles's original Chinatown, labeled here as Old Chinatown. Most of Old Chinatown was demolished in the 1930s to make way for Union Station, and a new Chinatown was constructed in its current location along Broadway. Ferguson Alley, the last remnant of the original Chinatown, remained until 1950, when it too was razed.

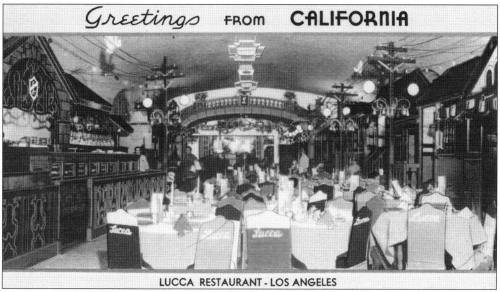

Greetings FROM CALIFORNIA

LUCCA RESTAURANT - LOS ANGELES

Lucca Restaurant, located on Western Avenue near Wilshire Boulevard, was a popular restaurant owned by Bert Rovere, who also operated the Paris Inn. The caption on the postcard's reverse advertises the restaurant's "unique Pokerchip Bar, Coffee Shop, and Curio Shop," and notes that it "Comfortably seats 500 in an air cooled atmosphere." The restaurant closed in the mid-1950s.

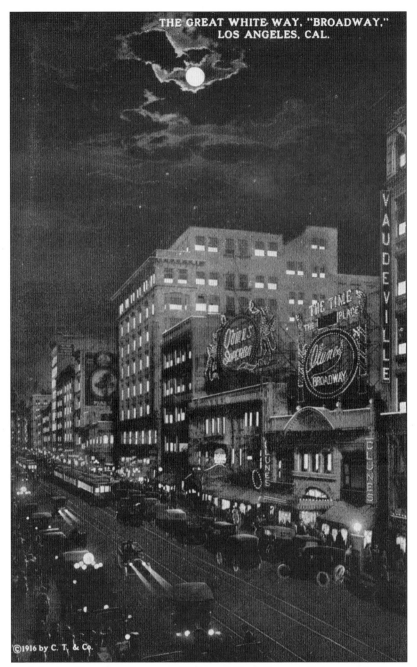

This postcard depicts Broadway between Fifth and Sixth Streets, facing north. By the time of this 1916 image, Broadway was the entertainment and shopping center of the city. Known as "The Great White Way" due to the large number of illuminated signs that lined the street, Broadway was home to major department stores and to an impressive concentration of vaudeville and movie theaters. The two theaters shown here are Quinn's Superba, at right, opened in 1914, and Clune's Broadway Theater, opened in 1916. While Quinn's was demolished in 1931 and replaced by the Roxie Theater, Clune's was later renamed the Cameo Theater and is currently used as a storefront.

102

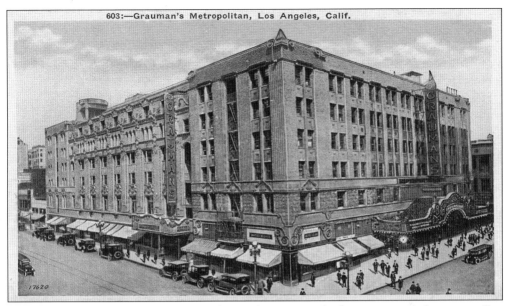

603:—Grauman's Metropolitan, Los Angeles, Calif.

With 3,600 seats, Grauman's Metropolitan Theater was the largest among downtown Los Angeles's concentration of theaters. Located at Hill and Sixth Streets, the 1923 theater was the second to be constructed by Sid Grauman downtown, following the 1918 opening of his Million Dollar Theater on Broadway. Later obtained by Paramount Pictures, the theater was renamed the Paramount Theater in 1929. While most downtown movie palaces still stand, the Metropolitan was demolished in 1963.

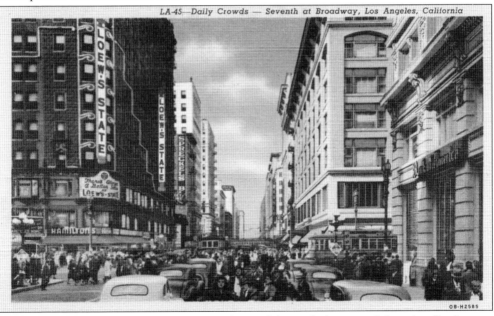

LA-45—Daily Crowds — Seventh at Broadway, Los Angeles, California

Broadway and Seventh Street, located in the heart of the city's theater and shopping district, was one of downtown Los Angeles's busiest intersections by the 1920s. Obtaining immediate success due to its prime location, Lowe's State Theater, at left, was the largest theater on Broadway when it opened in 1921. As suburban theaters gained popularity, downtown's movie palaces began to close. Lowe's Theater ceased showing movies in 1998.

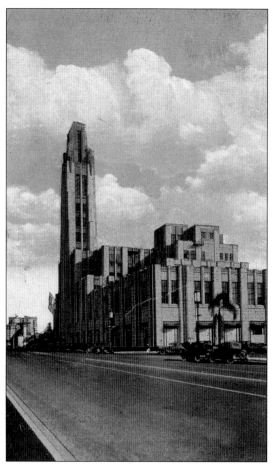

As the popularity of the car increased, commercial districts began to develop outside of downtown Los Angeles. Wilshire Boulevard was one of the most important of the new districts, with many major department stores relocating or opening branches there beginning in the 1920s. This 1934 postcard depicts Bullocks Wilshire, which opened in 1929. Though the store closed in 1993, the well-known art deco building now serves as home of the Southwestern Law School.

Located in Culver City, Helms Bakery was for several decades one of Los Angeles's most well-known bakeries. Opened in 1931 by Paul Helms, the bakery featured the slogan "Daily at your door." Every weekday morning Helms trucks departed the bakery with fresh bread and baked goods to be delivered to homes throughout the Los Angeles basin. The bakery closed in 1969, as supermarket competition caused it to become too costly to send so many trucks daily throughout the region. The famous building remains and is currently occupied by furniture showrooms and restaurants as part of the Helms Bakery District.

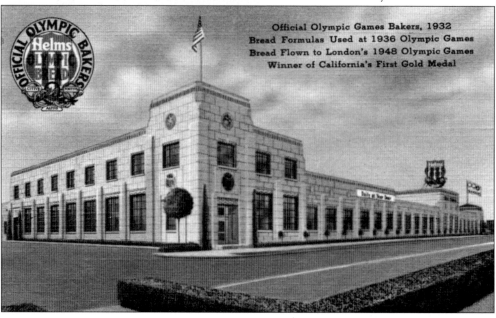

Official Olympic Games Bakers, 1932
Bread Formulas Used at 1936 Olympic Games
Bread Flown to London's 1948 Olympic Games
Winner of California's First Gold Medal

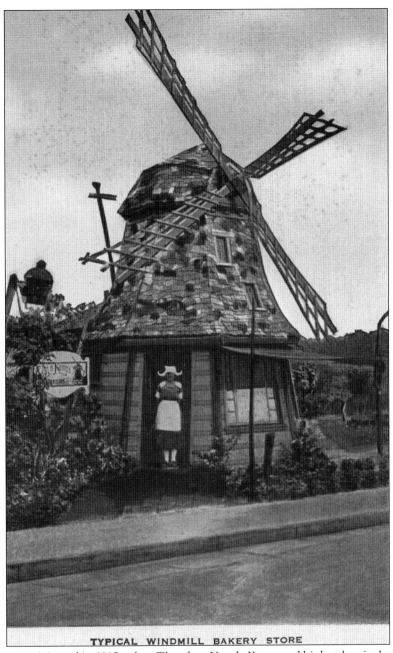

TYPICAL WINDMILL BAKERY STORE

Van de Kamps originated in 1915, when Theodore Van de Kamp and his brother-in-law Laurence Frank opened a potato chip stand in downtown Los Angeles. The company soon expanded to feature an extensive line of bakery items, and windmill-shaped Van de Kamps bakeries began appearing throughout Los Angeles in the 1920s. To complete the theme, clerks dressed in blue and white Dutch-style uniforms. As supermarkets gained popularity in the 1930s, supermarket outlets were added. By the time it was acquired by the General Baking Company in 1956, Van de Kamps had expanded to include several coffee shops and a drive-in, all featuring the famous windmill. Though the name was purchased for use by Ralphs Grocery Stores, the original Van de Kamps baked goods disappeared for good when they closed their Los Angeles factory in 1990.

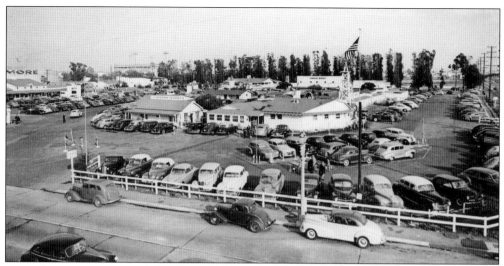

One of Los Angeles's best-known places, the Los Angeles Farmers Market at Third Street and Fairfax Avenue dates to 1934, when a dozen local farmers began meeting in the field of a former dairy farm to sell their wares from the backs of their trucks. The market was so successful that wooden stalls were soon added. The market continues to operate, now adjacent to the Grove, an upscale outdoor shopping mall.

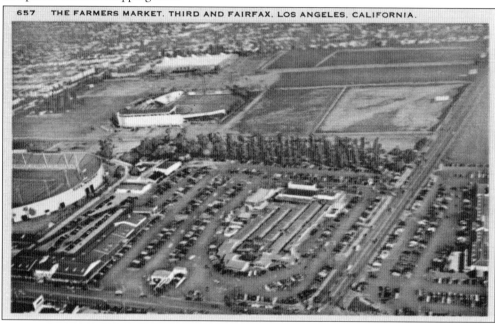

This postcard provides an aerial view of the Los Angeles Farmers Market as it appeared in its early days. A former dairy farm, the land belonged to the Gilmore family, who owned the Gilmore Oil Company and several gas stations. Earl Gilmore also opened the two other landmarks seen in this postcard: Gilmore Stadium, at bottom left, in 1934, and the adjacent Gilmore Field in 1938. The stadium, built for racing midget autos, became the home of the Bulldogs, Los Angeles's first professional football team. The field was used by the Hollywood Stars, a minor league baseball team. Both the stadium and the field were razed in the 1950s, and the site was used to construct CBS Television City.

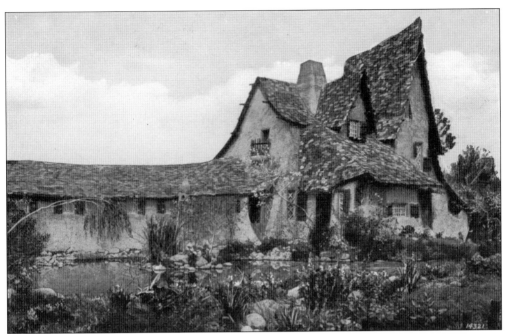

Constructed in 1921 in Culver City, this unique storybook-style building was first used as the offices and dressing rooms of silent film maker Willat Studios. After the studio closed several years later, the fanciful structure was moved to Beverly Hills. Often referred to as the "Witch's House," the restored building is currently a private residence.

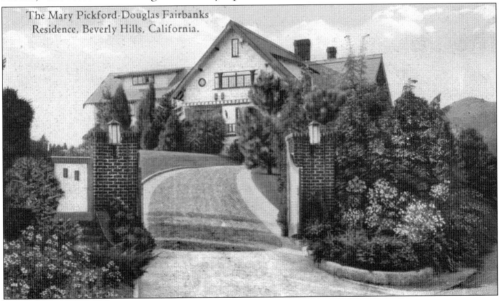

The homes of movie stars were frequent subjects of early postcards, as the rest of the country longed to see how their favorite stars lived. No Hollywood couple was more loved than Douglas Fairbanks and Mary Pickford, and their Beverly Hills home, known as Pickfair, was of prime interest. Known as a Hollywood social center in the 1920s, Pickfair's parties were attended by numerous celebrities of the day. Following their divorce in 1936, Pickford continued to reside in the home until her death in 1979. The legendary home was demolished in the late 1980s.

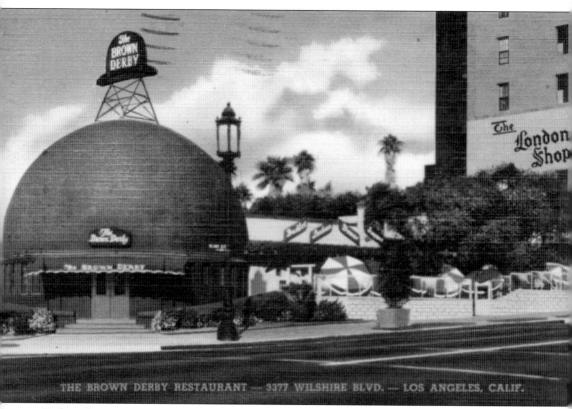

THE BROWN DERBY RESTAURANT — 3377 WILSHIRE BLVD. — LOS ANGELES, CALIF.

Perhaps bygone Los Angeles's most famed landmark, the original hat-shaped Brown Derby restaurant opened on Wilshire Boulevard across from the Ambassador Hotel in 1926. The hat shape originated when creator Herbert Somborn was supposedly told by screenwriter Wilson Minzer, "If you know anything about food, you can sell it out of a hat." The all-night restaurant gained popularity with movie celebrities, prompting the addition of three other locations. After Somborn's death in 1934, the restaurant came under the ownership of manager Robert Cobb, who gained fame for creating the Cobb salad and for his ability to cater to celebrity whims. The famous hat restaurant closed in 1975, and a strip mall was constructed on the site in 1980.

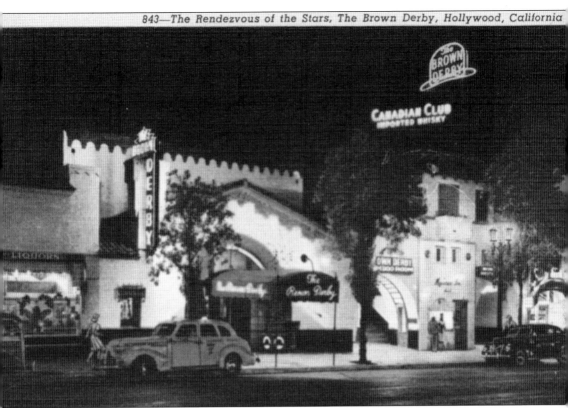

The second Brown Derby location opened in Hollywood on Valentine's Day in 1929. Though designed in Mission Revival style instead of as a hat, the restaurant became one of Hollywood's premiere celebrity hotspots, helping to establish Hollywood Boulevard and Vine Street as one of the city's most desirable locations. As at the Wilshire eatery, caricatures of celebrities that had visited lined the walls, and the restaurant became known as the "rendezvous of the stars." A third Brown Derby opened in Beverly Hills in 1931, and a fourth opened in 1940. Despite their iconic status, one by one the restaurants closed. The original hat closed in 1975, the Beverly Hills restaurant was demolished in 1983, and the Hollywood location was destroyed by fire in 1987. The Los Feliz branch, vacated by the restaurant in 1960, is the only Brown Derby structure still standing.

This postcard pictures the interior of Mike Lyman's Grill on Sixth Street in downtown Los Angeles. A former vaudeville entertainer, Mike Lyman entered the restaurant business in Los Angeles in the 1920s. In 1935, he opened the first Mike Lyman's Grill at Hill and Eighth Streets. Lyman also operated a third location in Hollywood, near the famed Hollywood Boulevard and Vine Street intersection.

Located next to Paramount Studios on Melrose Avenue, the Nickodell Restaurant was popular with the movie crowd. The restaurant opened in 1936 when Nick Slavich purchased what had been the Melrose Grotto and renamed it after himself. Movie crews, celebrities, and television stars all frequented the restaurant, including Lucille Ball and Desi Arnaz, whose Desilu Studios was just down the street. The restaurant closed in 1993, and the site is now a parking lot for Paramount Studios.

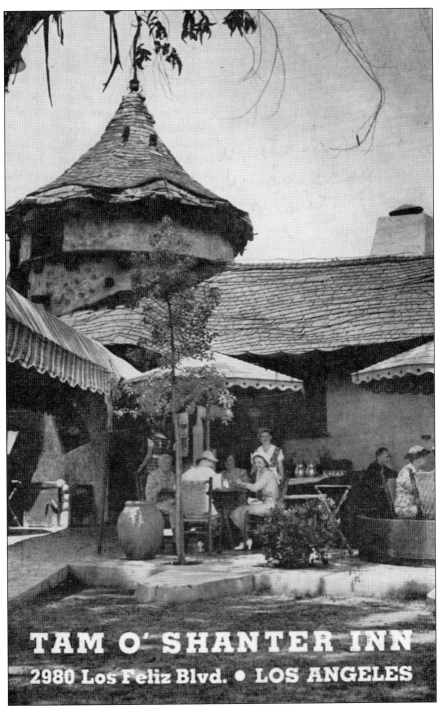

TAM O' SHANTER INN

2980 Los Feliz Blvd. • LOS ANGELES

Postmarked in 1941, this postcard depicts the Tam O'Shanter Inn on Los Feliz Boulevard. The Scottish-themed restaurant was opened by Lawrence Frank and Walter Van de Kamp in 1922. Although the Old World–style restaurant was renamed the Great Scot in 1968, its original name was restored in 1982. Still operated by family members of the original founders, the Tam O'Shanter continues to exist as a unique Atwater Village landmark.

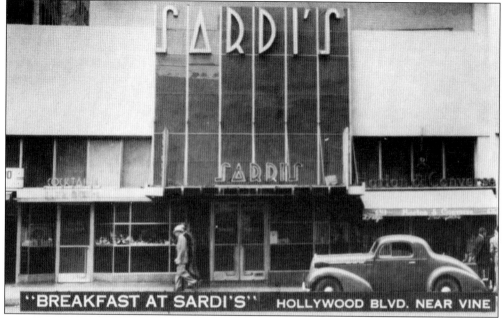

"BREAKFAST AT SARDI'S" HOLLYWOOD BLVD. NEAR VINE

Sardi's Restaurant, a favorite spot for many Hollywood stars, opened in 1932 on Hollywood Boulevard near Vine Street. With a notable modernist exterior designed by Rudolph Schindler, Sardi's featured a unique tiered dining area. This setup attracted entertainer Tom Breneman, who in 1941 began broadcasting his popular morning radio show "Breakfast at Sardi's," later renamed "Breakfast in Hollywood," from the restaurant.

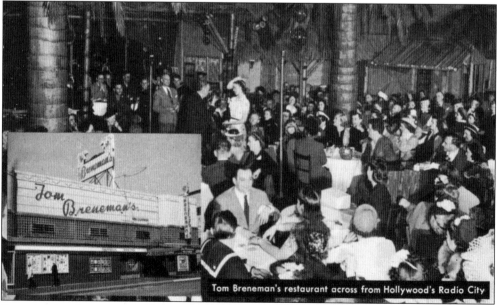

Tom Breneman's restaurant across from Hollywood's Radio City

Experiencing huge success from his radio broadcast show "Breakfast in Hollywood," Tom Breneman decided to open his own restaurant in 1945. The new restaurant was located on Vine Street near Hollywood Boulevard, not far from Sardi's, where the famous radio show had got its start in 1941. The restaurant closed and the radio show came to an end after Breneman's death in 1948.

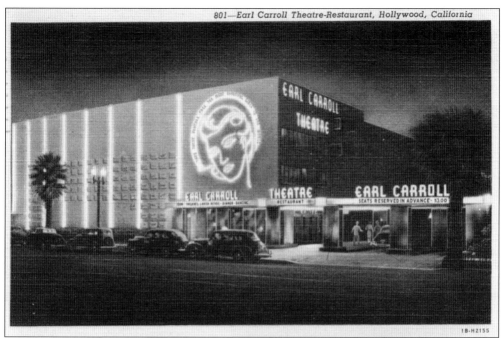

801—Earl Carroll Theatre-Restaurant, Hollywood, California

Opened by Earl Carroll in 1938, the Earl Carroll Theater on Sunset Boulevard featured over 1,000 seats, from which visitors enjoyed the nightly entertainment on its famous revolving stages. Known for its lavish revues, the theater was a popular night spot frequented by Hollywood celebrities. Emblazoned in neon near the entrance was the theater's famed motto, "Through these portals pass the most beautiful girls in the world." Sold in 1948 after Carroll was killed in a plane crash, the theater has since 2004 been operated by Nickelodeon Studios as the site for some of its live-action shows.

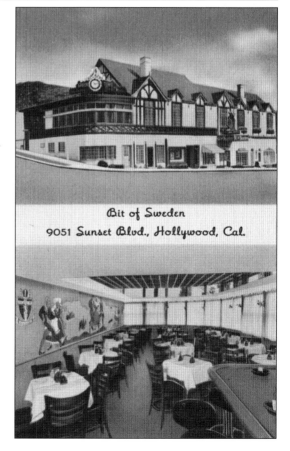

Bit of Sweden
9051 Sunset Blvd., Hollywood, Cal.

This postcard depicts the Bit of Sweden restaurant, located on the Sunset Strip in Hollywood. The Scandinavian-style eatery reached the height of its popularity in the 1930s and 1940s, offering a smorgasbord advertised to be the largest in the world. Longtime chef Kenneth Hansen left in 1946 to open the Scandia restaurant, another famed Sunset Strip locale.

113

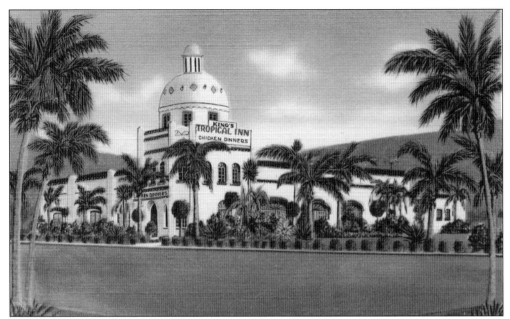

King's Tropical Inn was one of several popular clubs and restaurants to line Washington Boulevard in Culver City beginning in the 1920s. Known for its fried chicken and for its tropical theme, the original restaurant opened in 1924. A second location, also on Washington Boulevard, opened in 1930 in the distinctive Moorish-style building shown here. The structure was demolished after being heavily damaged by the 1994 Northridge earthquake.

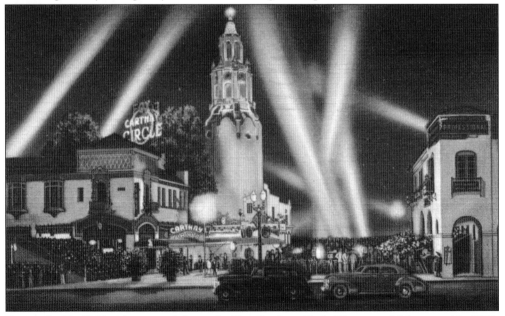

Postmarked in 1946, this postcard shows the Fox Carthay Circle Theater, which opened in 1926. Located on San Vicente south of Wilshire Boulevard, the theater was part of a development by J. Harvey McCarthy in the 1920s. The 1,500-seat Mission Revival–style theater, with its distinctive bell tower, was a favorite choice for Hollywood movie premieres. The well-loved theater was demolished in 1969.

Six

THE ROADSIDE ERA

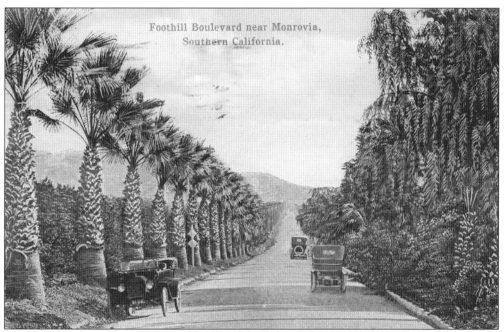

Foothill Boulevard near Monrovia,
Southern California.

Los Angeles's love of the automobile developed early, becoming a favorite pastime and giving rise to a vibrant car culture. New subdivisions lured buyers with advertisements of fine roads, and architectural styles began to be geared toward attracting motorists. By the 1930s, Los Angeles County residents had more cars per capita than anywhere in the nation other than the auto manufacturing city of Detroit. Postmarked in 1924, this postcard depicts Foothill Boulevard, one of the county's acclaimed tree-lined boulevards. When Route 66 was designated in 1926, Foothill Boulevard became part of the famed Mother Road, by which millions of migrants and tourists would arrive in Los Angeles over the next several decades.

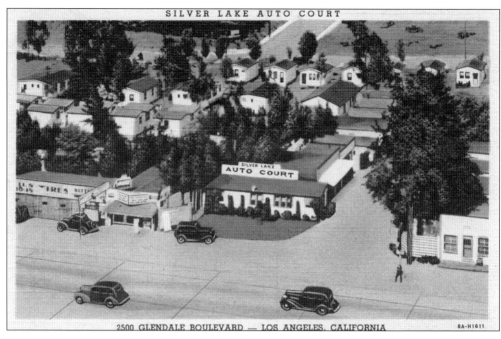

SILVER LAKE AUTO COURT

SILVER LAKE
AUTO COURT

2500 GLENDALE BOULEVARD — LOS ANGELES, CALIFORNIA 8A-H1611

As auto travel began to become common in the 1920s, a new type of lodging catering specifically to motorists began developing as an alternative to traditional hotels. Known as auto courts, motor courts, and later as drive-in motels, the new style featured affordably priced individual units, next to which patrons could park their vehicles. The 1920s postcard above provides an overlook of the individual bungalows of the Silverlake Auto Court. The postcard below pictures Stillwell's Auto Hotel, which offered 125 units at their location two miles east of Union Station. As was true with many auto courts, Stillwell's had its own café and service station.

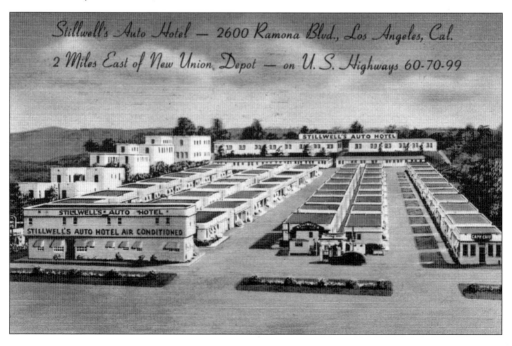

Stillwell's Auto Hotel — 2600 Ramona Blvd., Los Angeles, Cal.
2 Miles East of New Union Depot — on U. S. Highways 60-70-99

STILLWELL'S AUTO HOTEL

STILLWELL'S AUTO HOTEL
STILLWELL'S AUTO HOTEL AIR CONDITIONED

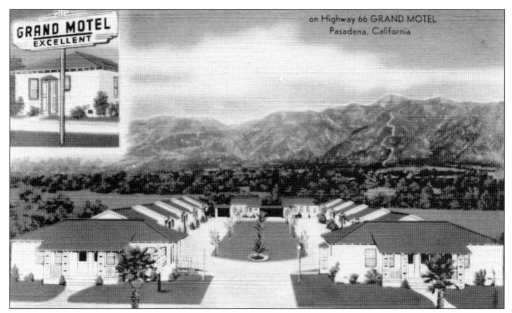

U.S. Highway Route 66 was designated in 1926, spanning over 2,400 miles from Chicago to Los Angeles. Gaining popularity as travel by car became commonplace, Route 66 ushered thousands upon thousands of tourists into Southern California. Responding to the needs of so many travelers, motels proliferated along the route. The Grand Motel, constructed in 1939, was located on Colorado Boulevard in Pasadena. Featuring the popular auto court layout, the motel offered moderately priced units, spaced so that guests could park beside their room.

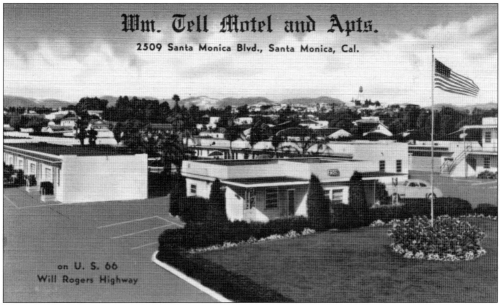

Though the original Route 66 alignment terminated at Broadway and Seventh Street in downtown Los Angeles, the route was soon extended to continue all the way to Santa Monica. For many travelers, the first view of the Pacific Ocean and the Santa Monica Pier was a welcome and satisfying sight, signifying the end of a long journey. The William Tell Motel and Apartments, an auto court with 110 units and a pool, boasted a Santa Monica location near the end of the route.

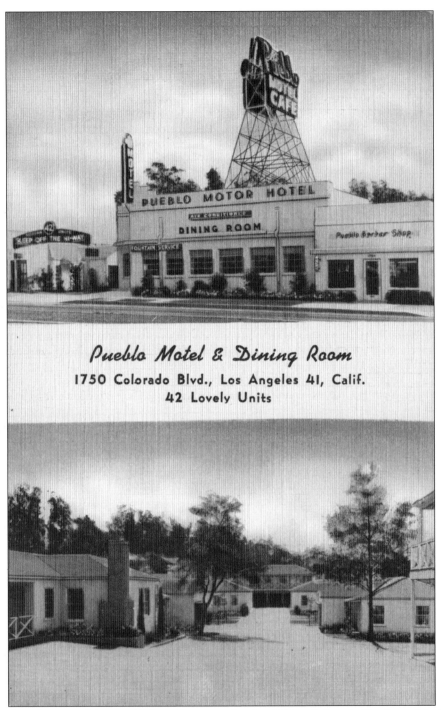

Pueblo Motel & Dining Room
1750 Colorado Blvd., Los Angeles 41, Calif.
42 Lovely Units

Though only part of Route 66 for a few years in the 1930s, Colorado Boulevard in Eagle Rock was nonetheless an important thoroughfare that attracted numerous roadside motels. With its distinctively large rooftop sign, the Pueblo Motel's entrance featured the logo "Sleep off the Hi-Way." The street facing portion of the 42-unit motel contained a dining room and a barbershop.

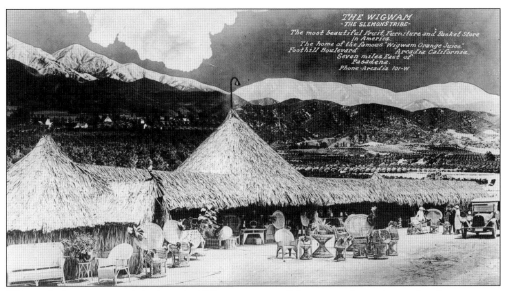

This real photo postcard depicts the Wigwam, one of the many themed stores and restaurants to open along Route 66. Located on Foothill Boulevard in Arcadia, the Wigwam sold fruits, furniture, and baskets, and was also "home of the famous Wigwam Orange Juice." Roadside stands selling locally grown fruit and orange juice were a common sight along Route 66.

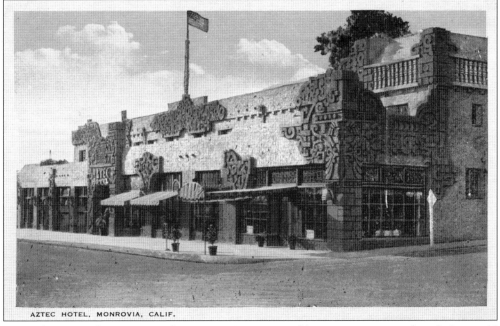

Opened in 1925, the Aztec Hotel in Monrovia was one of the most ornate motels early Route 66 travelers would have passed as they entered Los Angeles County. Robert Stacey-Judd designed the hotel in Mayan style, although he decided to name it the Aztec because he thought it would be more appealing to the general public. In addition to the elaborate ornamentation of the façade, the hotel was decorated with Mayan-themed murals and mosaics in the interior and the lobby. Though a realignment of Route 66 in 1931 bypassed the hotel, it continued to attract attention. The Aztec Hotel and its Mayan Bar and Grill are still in operation on Foothill Boulevard.

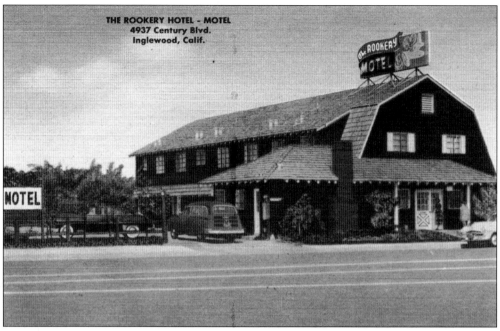

As car travel became standard, motel owners began to employ creative architectural styles in order to set themselves apart from the numerous roadside establishments that lined major thoroughfares. Motels built to resemble plantations, bungalows, teepees, Spanish missions, and ancient ruins began appearing throughout the county. The barn-shaped Rookery Motel was located on Century Boulevard in Inglewood.

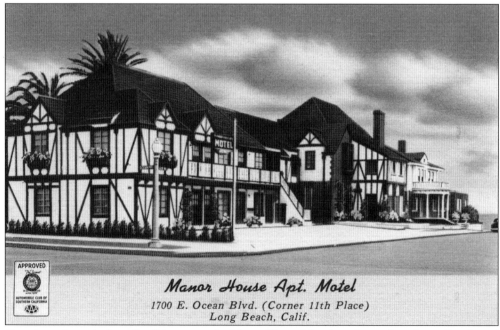

Constructed to mimic an English manor, the Manor House Motel was located on Ocean Boulevard in Long Beach. As they offered an affordable and convenient place for families to spend their vacation, motels proliferated near popular attractions such as the beach.

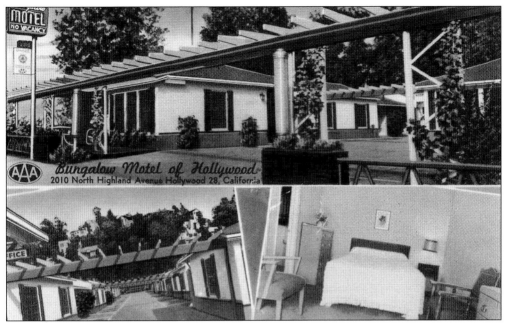

During the golden age of auto travel from the 1920s through the 1950s, families from around the country embarked on road trips to Los Angeles County, seeking to enjoy the weather, see the attractions, and often hoping to spot their favorite stars in Hollywood. As a top destination, motels in Hollywood abounded and were often constructed with themed architecture to draw in motorists. Postmarked in 1953, the above postcard pictures the Bungalow Motel, which was constructed on Highland Avenue in the popular Southern California bungalow style. The 1956 postcard below shows the colonial-style Hollywood Colonial Motor Hotel on Western Avenue. While the Bungalow Motel has been replaced with a larger hotel, the Hollywood Colonial continues to operate as the Coral Sands Motel.

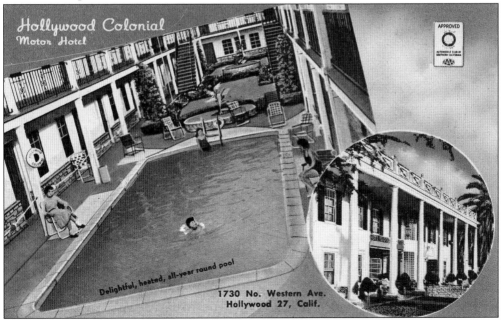

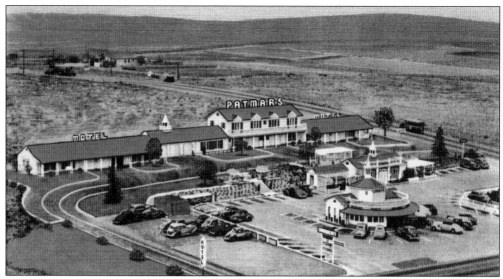

Postmarked in 1946, this postcard depicts PatMar's, an auto motel that also featured a café and a cocktail lounge. Operating in the 1940s and 1950s, the motel was located at the corner of Imperial Highway and Sepulveda Boulevard, near what is now Los Angeles International Airport. At the time of this postcard, the airport was a small city airfield located completely to the east of Sepulveda Boulevard and surrounded by wheat and barley fields. The author of this postcard compares the motel to others at the time, writing, "This is what I call a swell layout. There are lots of them here but not many as fine as this."

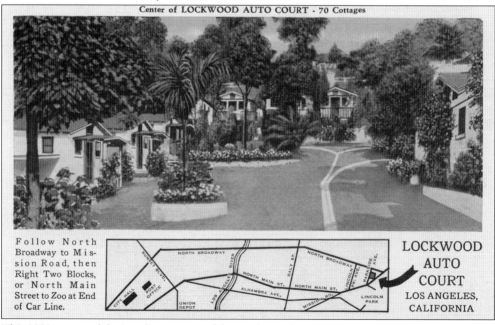

This 1920s postcard depicts the cottages of the Lockwood Auto Court, located near Lincoln Park. Travelers stopping here found themselves just a short distance from the attractions at Lincoln Park, including the Los Angeles Ostrich Farm, the Alligator Farm, and Selig Zoo. Though both the auto court and the animal farms have disappeared, many former visitors fondly recall that on quiet nights, cottage guests could hear the lions roaring from the nearby zoo.

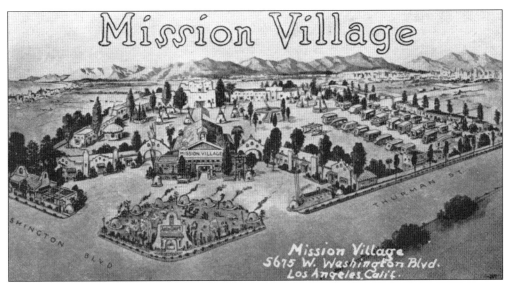

The Mission Village Auto Court was opened in 1926 on Washington Boulevard in Culver City by Robert Callahan, an early silent film actor and author of several books. Influenced by the popularity of Helen Hunt Jackson's 1884 novel *Ramona*, which had spurred a fascination with Spanish mission and Native American life, Callahan had originally planned to create an amusement park called Ramona Village. After encountering problems, Callahan instead created a themed tourist court motel.

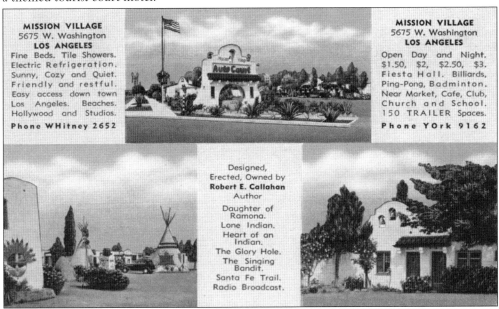

MISSION VILLAGE
5675 W. Washington
LOS ANGELES
Fine Beds. Tile Showers.
Electric Refrigeration.
Sunny, Cozy and Quiet.
Friendly and restful.
Easy access down town
Los Angeles. Beaches.
Hollywood and Studios.
Phone WHitney 2652

MISSION VILLAGE
5675 W. Washington
LOS ANGELES
Open Day and Night.
$1.50, $2, $2.50, $3.
Fiesta Hall. Billiards,
Ping-Pong, Badminton.
Near Market, Cafe, Club,
Church and School.
150 TRAILER Spaces.
Phone YOrk 9162

Designed,
Erected, Owned by
Robert E. Callahan
Author
Daughter of
Ramona.
Lone Indian.
Heart of an
Indian.
The Glory Hole.
The Singing
Bandit.
Santa Fe Trail.
Radio Broadcast.

After constructing teepees and pueblo-style lodgings for auto travelers, Robert Callahan added several historically themed attractions, including a kiva, the Ramona Chapel, and a small schoolhouse that replicated those used in early frontier settlements. Mission Village closed in 1962 in order for the 10 Freeway to be constructed. Several of the buildings were relocated to Canyon Country, where Callahan opened an attraction called Callahan's Old West. The schoolhouse and chapel were later donated to the Santa Clarita Valley Historical Society and can still be visited.

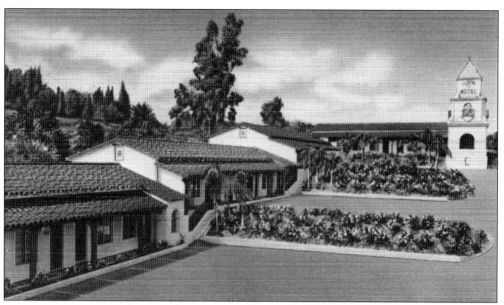

Drawing on the romance many tourists attached to the early Spanish days and the California missions, Mission Revival style surged in popularity throughout Southern California. This 1946 postcard shows the El Adobe Motel in Monterey Park. Constructed to resemble a mission, the scenic motel obviously appealed to the sender of the postcard, who wrote, "Isn't this an adorable place? We couldn't pass it up. It is even prettier in reality."

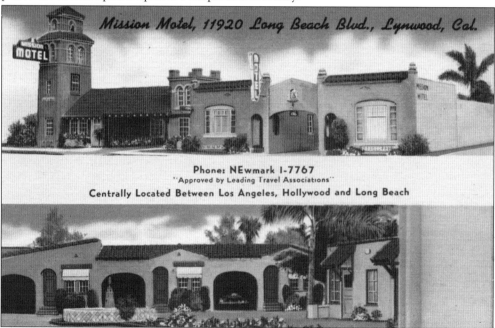

This postcard depicts another motel constructed in the popular mission revival style, the Mission Motel on Long Beach Boulevard in Lynwood. The bottom half of the image shows the arched carports between rooms where guests could park their vehicles. Although it still standing, many of the charming features of the motel have vanished, and the carports have been remodeled to serve as additional guest rooms.

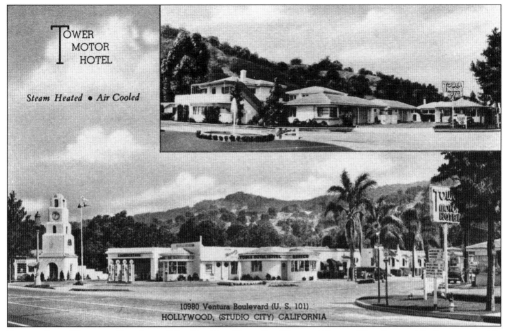

Located on Ventura Boulevard in Studio City, the Tower Motor Hotel provided guests with individual garages secured with modern garage doors. The motel also offered a service station, located near the motel's distinctive street facing tower.

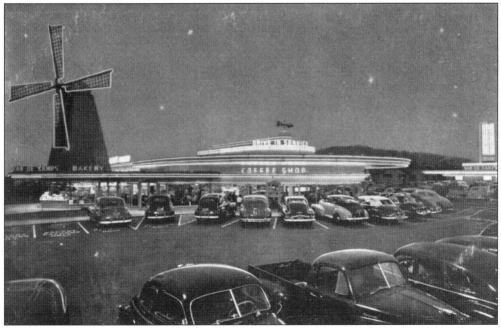

Van de Kamps Holland Dutch Bakery, which operated a chain of windmill-shaped bakeries as well as supermarket bakery outlets, had expanded by the 1940s to include several coffee shops. As car cafes became popular, Van de Kamps constructed their own drive-in café, seen here. Located at Fletcher Drive and San Fernando Road in Atwater, the streamline moderne building featured the bakery's hallmark, a rotating windmill, which was lit by neon lights at night.

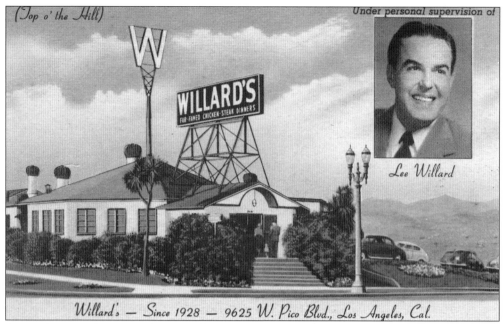

Under personal supervision of

Lee Willard

Willard's — Since 1928 — 9625 W. Pico Blvd., Los Angeles, Cal.

As cars became the accepted mode of travel, restaurants and stores began featuring designs to attract customers arriving by car. In addition to unusual architecture, large signs, such as the one seen here on top of Willard's Restaurant, became a common sight. Willard's, a well-known chicken restaurant, had two locations. The first one, seen here, opened on Pico Boulevard in 1928. The second location was added a year later on Los Feliz Boulevard. The Los Feliz branch, operated until 1940, gained fame when it was remodeled to become the fourth Brown Derby.

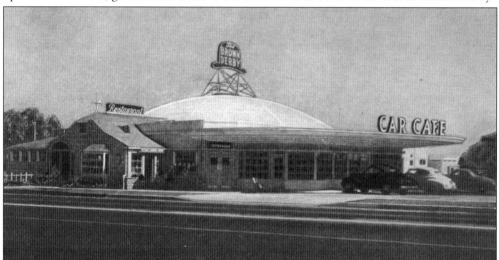

This postcard depicts the fourth Brown Derby location, which opened on Los Feliz Boulevard in 1940. Formerly Willard's Restaurant, the building was purchased by Cecil B. DeMille and redesigned to cater to the car culture that was exploding in popularity. Though the original hat-shaped Brown Derby on Wilshire Boulevard easily attracted drivers with its unique shape, the Los Feliz Brown Derby was the only one to include a drive-up car café in addition to the traditional dining room. Though the Brown Derby vacated this location in 1960, the building is the only one of the four Brown Derby structures to remain standing.

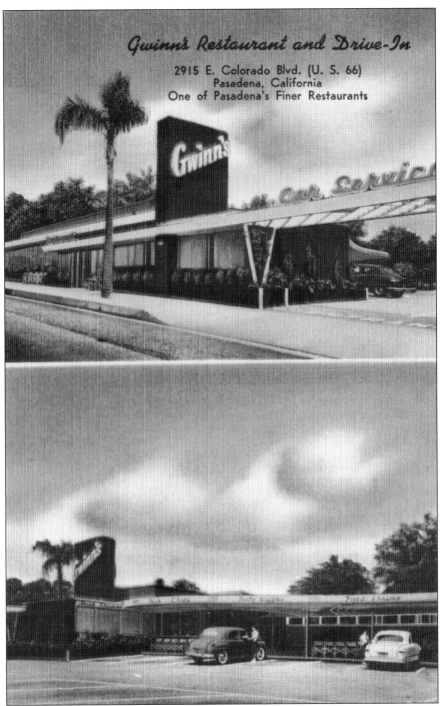

One of Pasadena's best-loved establishments, Gwinn's restaurant and drive-in was a prime example of roadside architecture. Featuring a street facing entrance constructed with a striking mid-century design, Gwinn's adopted the popular format of having both a dining room and car service. Located on Colorado Boulevard, Gwinn's was a popular local meeting spot and date night destination from 1949 to 1972.

www.arcadiapublishing.com

Discover books about the town where you grew up, the cities where your friends and families live, the town where your parents met, or even that retirement spot you've been dreaming about. Our Web site provides history lovers with exclusive deals, advanced notification about new titles, e-mail alerts of author events, and much more.

MADE IN THE

Arcadia Publishing, the leading local history publisher in the United States, is committed to making history accessible and meaningful through publishing books that celebrate and preserve the heritage of America's people and places. Consistent with our mission to preserve history on a local level, this book was printed in South Carolina on American-made paper and manufactured entirely in the United States.

This book carries the accredited Forest Stewardship Council (FSC) label and is printed on 100 percent FSC-certified paper. Products carrying the FSC label are independently certified to assure consumers that they come from forests that are managed to meet the social, economic, and ecological needs of present and future generations.

FSC

Mixed Sources
Product group from well-managed forests and other controlled sources

Cert no. SW-COC-001530
www.fsc.org
© 1996 Forest Stewardship Council

Find *Your* Place in History.